POSTCARD HISTORY SERIES

# La Crosse

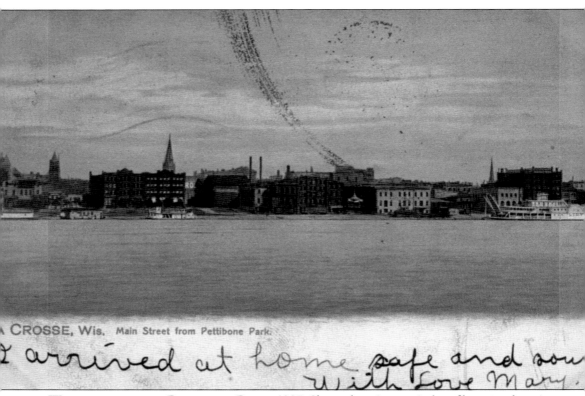

CROSSE, Wis. Main Street from Pettibone Park.

*I arrived at home safe and sou With Love Mary.*

**WATERFRONT FROM PETTIBONE PARK, 1907.** Shown here is a reminder of how much society has changed in the last century. Mary informs the recipient, Marie Ostreng, that following their visit she safely arrived home, completing the 18-mile trip from Stoddard to La Crosse. Today, that distance seems almost inconsequential, and the same information can be instantaneously communicated via cellular telephone, social media, e-mail, or text. (Courtesy of Special Collections, Murphy Library, University of Wisconsin–La Crosse.)

**ON THE FRONT COVER: RIVERSIDE PARK.** A family in Riverside Park watches the departure of the steamboat *Alexander MacKenzie*. This c. 1940 scene is not an uncommon sight today, as steamboats and families still routinely frequent the levee. The image is also reminiscent of a life-size bronze statue in the park of two children greeting steamboats, titled *A Simpler Time*. (Courtesy of Special Collections, Murphy Library, University of Wisconsin–La Crosse.)

**ON THE BACK COVER: MAIN STREET.** This 1930s view of Main Street features brick-lined streets and trolley tracks in downtown La Crosse. Farther back, the steeple of the old St. Joseph's Cathedral pierces the skyline. Several businesses of La Crosse's past are visible, including Liggett's Drugstore, Kinney Shoes, and the Odin Oyen interior-decoration firm. (Courtesy of Special Collections, Murphy Library, University of Wisconsin–La Crosse.)

POSTCARD HISTORY SERIES

# La Crosse

*Laura Godden and Paul Beck*

ARCADIA
PUBLISHING

Published by Arcadia Publishing
Charleston, South Carolina

Printed in the United States of America

Library of Congress Control Number: 2014944889

For all general information contact Arcadia Publishing at:
Telephone 843-853-2070
Fax 843-853-0044
E-mail sales@arcadiapublishing.com
For customer service and orders:
Toll-Free 1-888-313-2665

Visit us on the Internet at www.arcadiapublishing.com

*To Murphy Library, the University of Wisconsin–La Crosse, and all other
institutions of learning and historic preservation*

# CONTENTS

Acknowledgments

Introduction   7

1.   City of Parks   9

2.   A City at Work   33

3.   City People   57

4.   Building a City   79

5.   A City Alive   105

About Murphy Library   127

# ACKNOWLEDGMENTS

First and foremost, special appreciation goes to Edwin Hill, retired Special Collections librarian and La Crosse Area Research Center director, for his work in establishing a stellar local history–based collection in Special Collections, Murphy Library, University of Wisconsin–La Crosse. Murphy Library's postcard collection, the basis of this book, is undeniably a product of 50 years of Ed's dedicated labor. He unselfishly continues his commitment to the collection. Even 16 years after his retirement, he regularly brings in materials to expand the collection.

Professor Emeritus Leslie Crocker's research uncovering the history of La Crosse's architecture has been especially helpful in the crafting of this work. Moreover, Dr. Crocker often generously invites the authors of this book along on his historical quests. His wonderfully informative book *Places and Spaces: A Century of Public Buildings, Bridges, and Parks in La Crosse, Wisconsin* beautifully presents his research and findings to the community. Dr. Crocker and his website www.lacrosse-buildings.com are invaluable resources for the authors.

The authors would like to thank the entire Murphy Library staff for their encouragement and support during the writing of this book. Laura would also like to thank her parents, Tim and Nancy Godden, for all of their help and kind words. Additionally, a huge thanks is owed to Dave Lange, Andrea Anderson, Jacob Davis, Teri Holford-Talpe, and Dani Weber for helping proofread the manuscript for this book.

Lastly, a shout-out and general thanks go to the dedicated student workers of Special Collections. They espouse a willingness to learn, assist researchers, and improve the collection. These students are responsible for both safeguarding and making the holdings accessible to the community. Their commitment, productivity, and contributions are essential to the operations of the unit.

All images in this book appear courtesy of Special Collections, Murphy Library, University of Wisconsin–La Crosse.

# INTRODUCTION

The city of La Crosse, in order to survive, grow, and retain relevancy as a regional economic and cultural center, has undergone several evolutionary transformations over its history. It has gone from a Native American gathering place to a fur trading post and then from a pioneer village to a boom-and-bust logging town. After that, it morphed from a manufacturing, commerce, and industrial center to its current state as a regional leader in health care services and higher education. This monograph attempts to investigate, explain, and visually represent the years surrounding the transitional period at the turn of the 20th century that most markedly shaped the community.

The first person of European ancestry to establish permanent residency in La Crosse was 19-year-old Nathan Myrick. In 1842, he built a log cabin trading post near the confluence of the La Crosse, Black, and Mississippi Rivers in what would later become downtown La Crosse. The location, due to the favorable river geography that facilitated transport, was already an assembly point for trade, socialization, and athletic gatherings by Ho-Chunk, Ojibwe, and Sioux tribes. Before Myrick's arrival, French voyageurs had named the site Prairie La Crosse.

La Crosse maintained its trading post status until the early 1850s, when the population started to dramatically increase due to a growing commercialized sawmill industry dependent on tree reserves north of the city. Cut lumber was floated down the Black and Mississippi Rivers to the sawmills in La Crosse. By 1856, enough people lived in La Crosse to officially incorporate, and the Wisconsin State Senate chartered the city.

Two years later, the arrival of rail transport ushered in further economic growth and prosperity for the city, which was already an established steamboat port. Moreover, the new railroad connection transformed the social makeup and size of the city's population. New settlers included both established Americans from the eastern portion of the United States and European immigrants, many coming from Germany and Norway.

Arriving immigrants sought a higher standard of living, improved social status, and greater employment prospects. These desires included business and land ownership. Push factors for immigration in the 1860s included bad farming conditions in Norway and political and civic upheaval in Germany that sometimes resulted in forced conscription into the Prussian military. The influence of these immigrant groups on the city is clear, as La Crosse had German and Norwegian newspapers, churches, and social clubs. Later, in 1880, a wave of Bohemian immigrants joined the city. The State of Wisconsin promoted immigration to the area, distributing pamphlets and placing advertisements in newspapers in Western Europe.

The population boom of the late 1800s exacerbated the unceremonious displacement of the region's Native American inhabitants. Federal government policy initiated the removal of native peoples in 1836. Even though the government's major efforts subsided around 1880, fear and personal gain propelled settlers to encourage further displacement. The extraction of Native Americans from La Crosse is ironic, as Native Americans were the very people whom Nathan Myrick depended on for trade, which was the trade that spurred the establishment of the city in the first place. Additionally, the city is named after the Native American stickball sport that was often played at its location.

The prosperity of early La Crosse was dependent on trees, a finite natural resource. When the supply dwindled, the sawmill-based economy in La Crosse bottomed out. The sudden decline of the lumber industry starting in 1899 resulted in the direct loss of over 3,000 lumber jobs and countless more in related industries, such as blacksmithing, harness making, and carriage construction. The city's wealthy lumber barons and many of their employees left, traveling westward toward new pineries. As a result, the population of La Crosse stagnated for

approximately 20 years. It was no doubt a traumatic event that could have destroyed the city. Despite this situation, La Crosse fared better than many other cities struck by the same decline, partly due to having other established and diversified industries already in place.

Nineteen major business firms were founded following the end of the lumbering era in La Crosse from 1899 to 1904. The La Crosse Board of Trade worked diligently to attract new businesses to the area. The brewery industry was well established and growing. However, this was not enough to offset an overall drop in the number of persons employed in the city. Although the economic decline was painful, it could be argued that the death of the lumber industry ensured the long-term growth and diversification of manufacturing and production in La Crosse.

In spite of the economic turmoil, citizens at the start of the 20th century began to expect an improved standard of living, demanding modernized, improved, and greater city services. The public wanted paved streets, better street lighting, professional fire protection, reliable electricity, a park system, improved educational opportunities, clean drinking water, and efficient sewers. Major improvements to the city's infrastructure began under Wendell Anderson, who became mayor in 1899. The citizens' demands modernized the city and shaped its current infrastructure. By 1919, overall-improved living and economic conditions resulted in the sentiment that La Crosse had officially recovered from the lumber bust. An editorial in the *La Crosse Tribune and Leader Press* from February 12, 1919, boasts that La Crosse deserves comprehensive city planning as just "twenty years ago La Crosse was a deserted mill town," but through astute and resourceful adaptations, it has become "a prosperous industrial city."

The years following World War I until the Great Depression were prosperous for La Crosse, despite the negative impact of Prohibition on the city's brewing industry. In the 1920s, the city's population increased by almost 10,000 people. Many local businesses grew into or were absorbed by large manufacturing firms, thus further rooting prominent regional and national companies in the area.

The postcard medium is like that of a time capsule and thus is an appropriate format for an informal historical overview of a locale. In order for a postcard to be produced, the image's subject matter must have some sort of heightened significance. In addition to the visual, the short messages to friends and family recorded on many postcards provide the modern reader with a snidbit of the past. These shorthand accounts, much like the modern 140-character quips of Twitter, can be factual, witty, or personal, but in any case provide the reader with insight about past people and places. This book is a bit like time travel as it digests and interprets these everyday images and messages, while marking their place in the overall history of La Crosse.

# One

# CITY OF PARKS

Visitors to La Crosse ardently remark on its natural beauty, much of which is encompassed in the city's park system. From the peak of Grandad Bluff to the water's edge at Riverside Park, La Crosse provides both visitors and residents with a stunning array of nature that is enjoyed year-round.

As the 20th century began, the creation of parks became increasingly important to local leaders, in part inspired by A.W. Pettibone's gift of land for public use in 1890. Increasing industrialism in these years encouraged city residents seeking a respite from the urban landscape to visit the neighboring countryside. Travel out of the city, however, was not always convenient for citizens and became less practical as the city grew.

Instituted in May 1908, the La Crosse Board of Park Commissioners sought to establish areas dedicated to nature within the city limits both for the enjoyment of residents and for the beautification of the city. A number of significant parks were established between the years 1909 and 1912. The board enlisted nationally renowned landscape architect John Nolen to design a park system for the city.

In his 1911 report to the park commissioners, Nolen writes of the movement in favor of more and better parks in La Crosse. He states, "It was decided at once that . . . all the forms of recreation that river and bluffs make possible should be provided" in the city's park system. Nolen observes that the focus on park creation improves "the civic spirit of the entire community." As of 2014, the City of La Crosse maintains 45 parks, totaling around 1,400 acres.

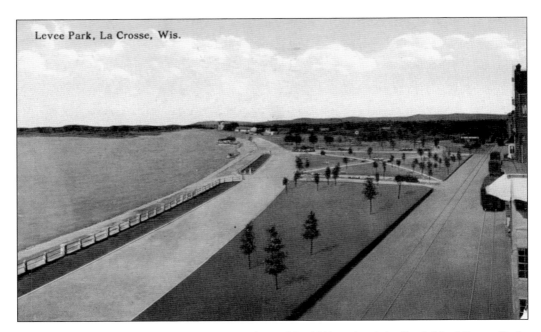

Levee Park, La Crosse, Wis.

**RIVERSIDE PARK, NOLEN'S DESIGN.** Dedicated in 1911 and originally dubbed Levee Park, Riverside Park is perhaps the most impressive and well-known park in La Crosse. Seen in the postcards here is the original ornamental design that renowned landscape architect John Nolen created for the 12-acre park. Nolen was a native of Cambridge, Massachusetts. He trained at the Harvard School of Landscape Architecture and is especially known for his work in the city of Madison, Wisconsin. Nolen also drew up a master park plan for La Crosse, which would have essentially created a 15-mile "continuous circuit" of parks throughout the city utilizing a series of parkways and boulevards, but that vision, unlike Riverside Park, was never actualized.

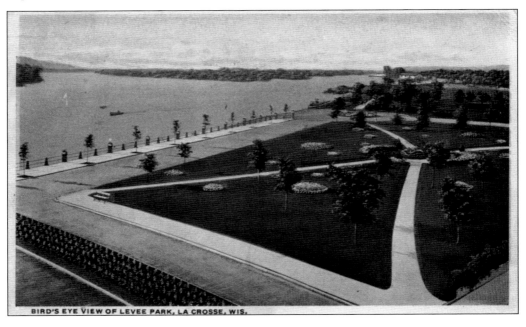

BIRD'S EYE VIEW OF LEVEE PARK, LA CROSSE, WIS.

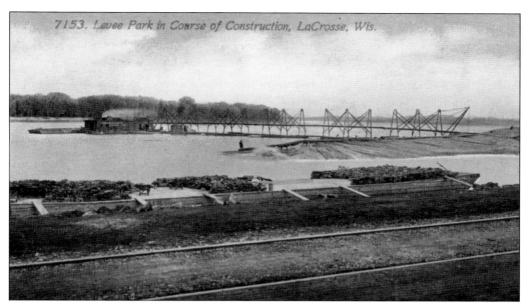

RIVERSIDE PARK, DREDGING, C. 1910. The creation of Riverside Park was a concerted effort. Mayor Wendell Anderson obtained land from several private owners, including the Milwaukee Railroad and the nearby Spence McCord Drug Company (the publisher of this postcard). Anderson also contracted the La Crosse Dredging Company to dredge the river for fill in order to create a larger expanse for the park.

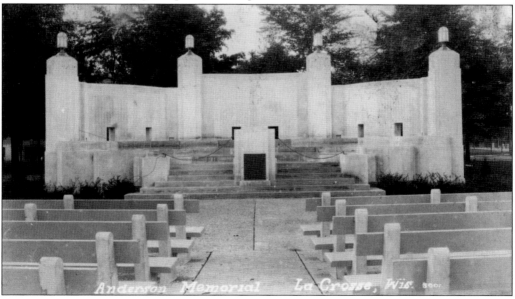

RIVERSIDE PARK, ANDERSON MEMORIAL. Built in 1930, the Wendell Anderson Memorial bandstand, named after the two-term mayor who oversaw Riverside Park's construction, replaced a wooden stage in the park. Local architect Otto Merman designed the Art Deco structure. In 1986, concrete additions were erected, significantly altering the design and detracting from the aesthetic appeal of the original cut stone. Currently, plans are underway to restore the structure to its original appearance

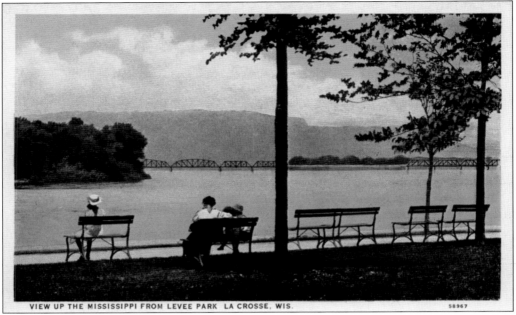

VIEW UP THE MISSISSIPPI FROM LEVEE PARK LA CROSSE, WIS.    58967

**RIVERSIDE PARK, BENCHES, THE 1920S.** Known for its spectacular views of the Mississippi River, Riverside Park underwent renovations in the 1990s that restored its historical ambience. Using old photographs for guidance, workers replaced benches, light posts, picnic tables, and trash receptacles with reproductions that closely resembled those in La Crosse's past. The people in this postcard image gaze at the railroad bridge and the distant bluffs of Minnesota.

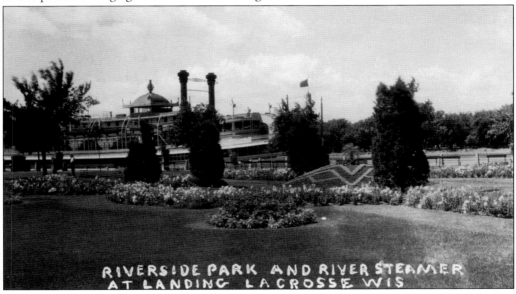

RIVERSIDE PARK AND RIVER STEAMER AT LANDING LA CROSSE WIS

**RIVERSIDE PARK, STEAMBOATS, C. 1920.** Steamboats often moored in Riverside Park after its completion in 1911. Although less numerous today, several steamboats still visit the park each year. Modern visitors include locally based steamboats like the *Julia Belle Swain* and nationally known steamboats like the *American Queen*. Seen here is the *Capital*. In the foreground of the image is a flower bed arranged in a star-shaped design in honor of Gold Star Mothers.

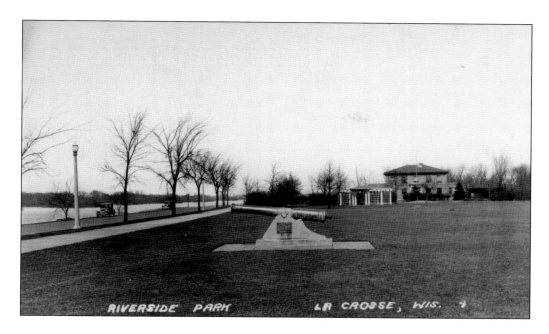

**RIVERSIDE PARK, ADDITIONS.** Over the years, several additions to Riverside Park have significantly altered John Nolen's original vision. The image above shows a 1787 Spanish-made cannon, captured during the 1898 Spanish-American War; it was added to the park in July 1918. In the image below is a gazebo that was donated to the city in 1920 and is still located in the park in an altered pergola form. Other additions not seen here include a fountain made from the marble stairs of the demolished county courthouse added in 1981, an international friendship garden added in 2004, and several sculptures. In the 1990s, the city instituted a major $1.1 million revamp of Riverside Park, during which great care was taken to make renovations sympathetic to modern uses of the park and Nolen's original 1911 design.

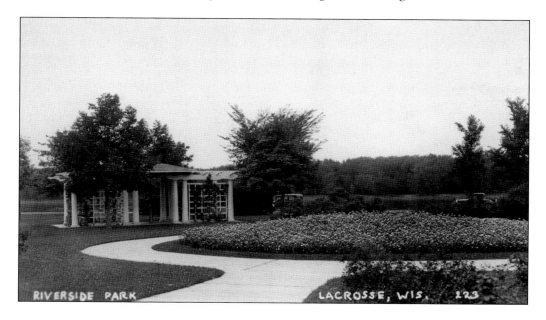

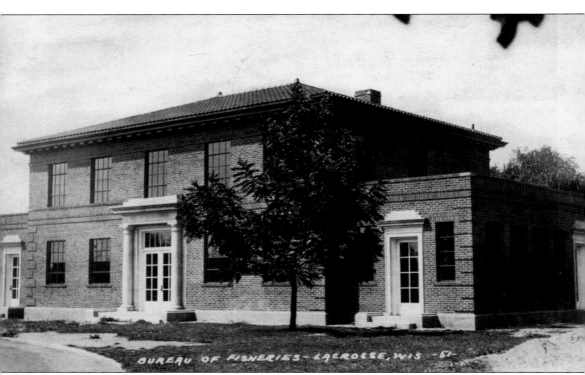

RIVERSIDE PARK, FISH LABORATORY. Another addition to Riverside Park took place in 1924 when the federal government constructed the fish control laboratory pictured here. The back of the postcard, written in 1926, reads, "Dear Bernard– This is the fish hatchery we went thru yesterday. They have tanks of every kind of fish there and a big owl in a cage in one window and underneath 1/2–dz alligators and a big bullfrog. –Mother." For the first 35 years, the primary function of this institution was rearing trout and largemouth bass for stocking needs. The employees also rescued fish that would get trapped in isolated pools when the high spring waters receded too quickly. The Army Corps of Engineers' Nine-Foot Channel Project rendered this service obsolete around the year 1940. In 1960, the focus of the institution shifted to fishery research, and modern science facilities and a library were added to the building, along with a public aquarium. In 1978, this building reverted to city ownership when the federal research operation relocated to a new facility on French Island.

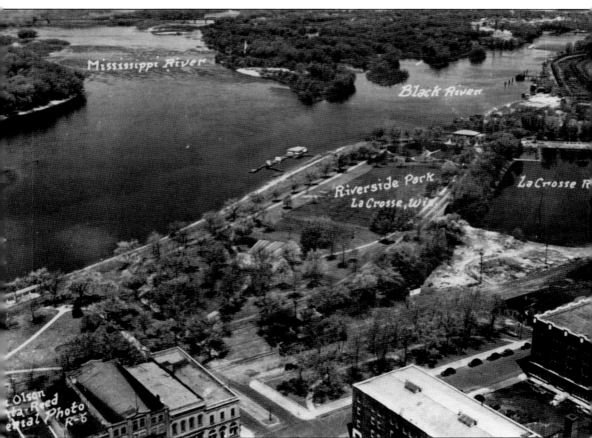

**RIVERSIDE AND SPENCE PARKS, AERIAL.** This image provides a bird's-eye view of Riverside Park, which is located near the confluence of three rivers. It also shows Spence Park, located on the eastern border of Riverside Park. Railroad tracks (now removed) once separated the two parks. Officially named in 1903, Spence Park is a 300-by-118-foot rectangle at the corner of Front and State Streets. A small decorative retaining wall used to define the park's perimeter. Before the Riverside Park area was filled in, Spence Park was known as the public landing and hosted an array of steamboat traffic. Spence Park is also the approximate location of Nathan Myrick's 1842 log cabin. The park was named after alderman and drugstore owner Thomas Spence. His wholesale building was located across the street from the park. Spence and C. Stevens gifted the land to the city for park purposes in 1898.

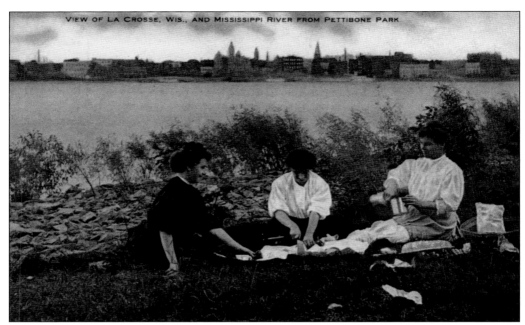

**PETTIBONE PARK, PICNICKERS.** In his 1911 report, John Nolen writes, "Pettibone Park was the beginning," even though parks like Burns and Myrick Park had existed before the establishment of Pettibone in 1890. Nolen reports that A.W. Pettibone's gift of the river island to create a "public pleasure ground . . . first supplied the demand for public parks and then created an insistent demand for more."

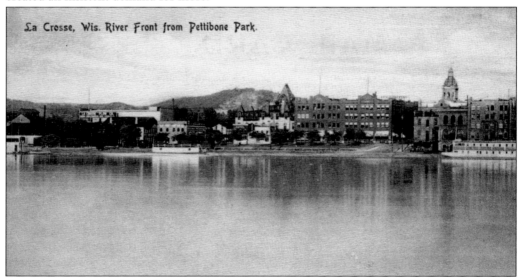

La Crosse, Wis. River Front from Pettibone Park.

**PETTIBONE PARK.** Behind the picnickers in the previous postcard and also seen here is the one-of-a-kind view of downtown La Crosse from Pettibone Park, located on Barron Island. In 1857, Alonzo Barron made public his intentions to create a Venice-like "Island City" on the space; however, he never implemented his plan. Around 1885, friends "Buffalo Bill" Cody and Doc "White Beaver" Powell purchased the land with the rumored intent to revive Barron's idea, which also never happened.

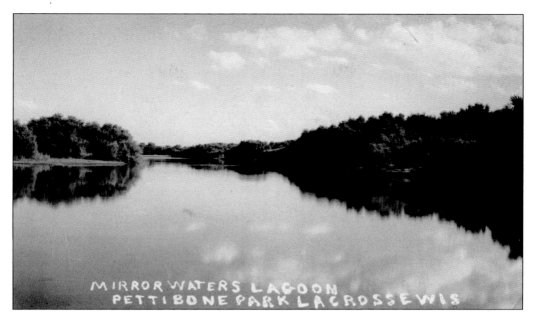

MIRROR WATERS LAGOON
PETTIBONE PARK LACROSSE WIS

**PETTIBONE PARK, LAGOON.** John Nolen describes Pettibone Park as having "picturesque and beautiful lagoons." He boasts that "if properly developed [Pettibone Park] might easily rival the famous Belle Isle Park of Detroit." Nolen proclaims that "the views of river scenery are much finer than those from Belle Isle." Before prominent lumberman and former La Crosse mayor A.W. Pettibone's 1890 efforts, the park was a marshy and unkempt land that harbored brothels frequented by lumbermen. Pettibone invested several years work and $212,000 to acquire, improve, and care for the 200 acres he named Island Park. On the 1907 postcard below, F.W. Tillman informs the recipient that Pettibone Lagoon "is a fine fishing place."

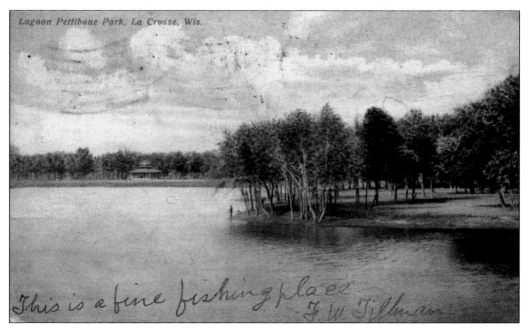

Lagoon Pettibone Park, La Crosse, Wis.

This is a fine fishing place
F. W. Tillman

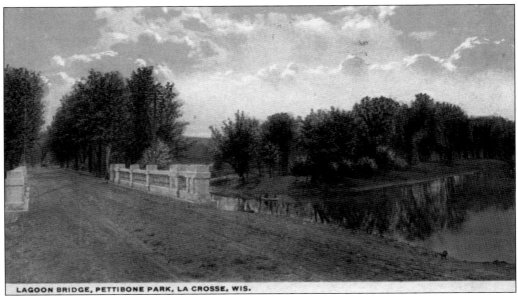

LAGOON BRIDGE, PETTIBONE PARK, LA CROSSE, WIS.

**PETTIBONE PARK, LAGOON BRIDGE.** In 1907, a $5,200 concrete bridge (pictured here) replaced the wooden bridge to Pettibone Park. In 1931, that bridge was replaced with the current lagoon bridge. Over the years, the 15-acre, spring-fed lagoon has hosted many outdoor activities, including fishing, canoeing, and ice-skating. A.W. Pettibone wanted to create a park for the working class. He wrote that he hoped that those "whose pleasures are few, may always find rest and freedom from care in the island across the river." Unfortunately, Pettibone died before the conclusion of the 15-plus-year struggle to transfer the park, which was then part of Minnesota, to Wisconsin ownership. The transfer finally took place in 1918 when both states settled on an island exchange. Both the US Congress and Pres. Woodrow Wilson had to sign off on the agreement.

Designed and Built by Marsh Bridge Co. Des Moines Ia
CONCRETE STEEL BRIDGE IN PETTIBONE PARK LA CROSSE W S
We Want to Build your Bridges Inquiries Solicited

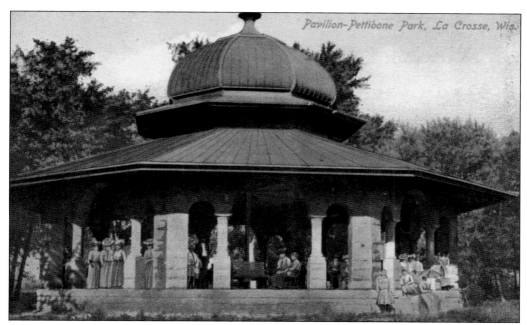

PETTIBONE PARK, GAZEBO–PAVILION. Construction on the octagonal gazebo, made from distinctive red Minnesota sandstone, was completed in 1903 and funded by A.W. Pettibone. Even though Pettibone had deeded Barron Island and a $50,000 trust for maintenance to a private park commission in 1901, he continued to personally fund many park improvements until his death in 1915. At the suggestion of John Nolen, seven years after Pettibone's death, his efforts were memorialized in the park with a plaque on a giant 21-ton boulder, trekked by railcar from Milwaukee to La Crosse. Upon its arrival in La Crosse, the city engineer said the rock was too heavy to travel across the wagon bridge, so a barge borrowed from the federal government brought it over to the park. It was placed near the gazebo, where it is still found.

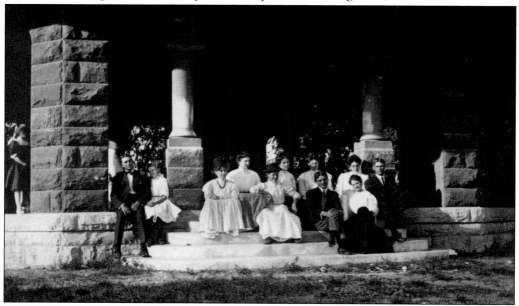

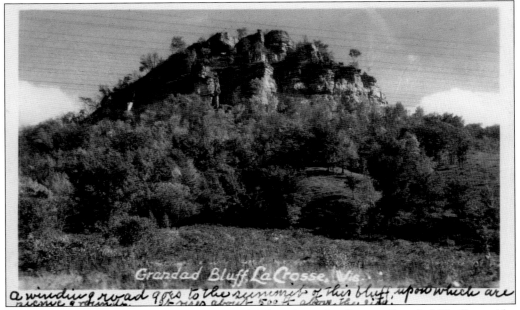

*Grandad Bluff La Crosse, Wis.*

*a winding road goes to the summit of this bluff, upon which are ...*

**GRANDAD BLUFF, BLISS ROAD.** Rising 600 feet above La Crosse, Grandad Bluff provides a spectacular view of the Driftless Area, so named because Ice Age glaciers circumvented the region. Due to a lack of flattening glaciation, La Crosse and the surrounding area are endowed with a series of picturesque bluffs and coulees. On the front of the postcard above, the writer describes their ascent to the top of Grandad Bluff. The road to the top of the bluff is named after Henry Bliss, a Yale-educated Connecticut native who came to La Crosse in 1855. He was the city engineer from 1860 to 1884 and also owned a summer residence on Grandad Bluff.

BLUFF DRIVE, LA CROSSE, WISCONSIN

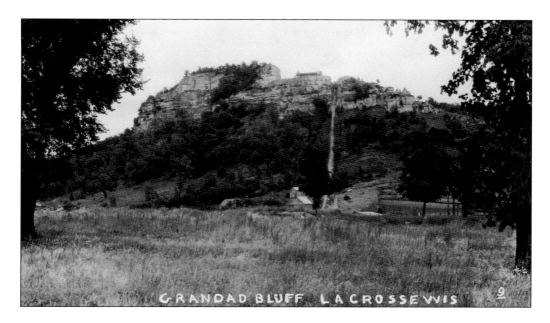

GRANDAD BLUFF LA CROSSE VVIS

**GRANDAD BLUFF, TRAMWAY.** Grandad Bluff Park is perhaps the most iconic and unique park in La Crosse. However, the bluff as it is today almost did not exist. This now fundamental element of La Crosse was almost destroyed in order to provide the needed foundation stone to construct the city. Its quarries provided the rock for basements, foundations, and area roads. Quarrying on Grandad Bluff began in the 1860s. These c. 1925 postcards show the 750-foot tramway on the face of the bluff used to transport limestone quarried at the top to the crusher building below. The tramway was a narrow-gauge track on which two open-car carts transported rock. Using gravity and cables, the weight of the loaded descending car was used to pull the empty car at the bottom back to the top.

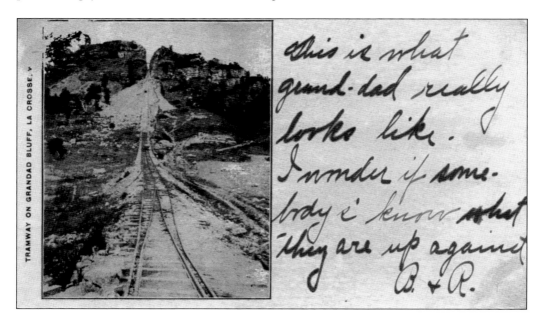

TRAMWAY ON GRANDAD BLUFF, LA CROSSE, V

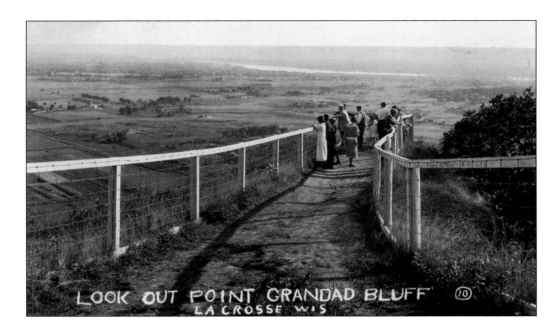

GRANDAD BLUFF, LOOKOUT POINT. From 1909 to 1912, Ellen Hixon, wife of prominent lumber baron Gideon Hixon, spearheaded an effort with several other private citizens to purchase Grandad Bluff in order to ensure the preservation of its natural beauty and breathtaking views. This group worried that continued quarrying on the bluff would completely destroy it. Members raised $15,000 so that the city could buy the site. The park opened to the public in 1912. The lookout point (featured in the above c. 1920 postcard) was recently renovated in 2012. It is still a popular lookout for residents and tourists alike.

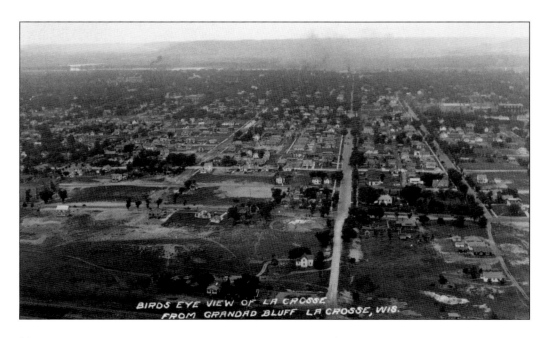

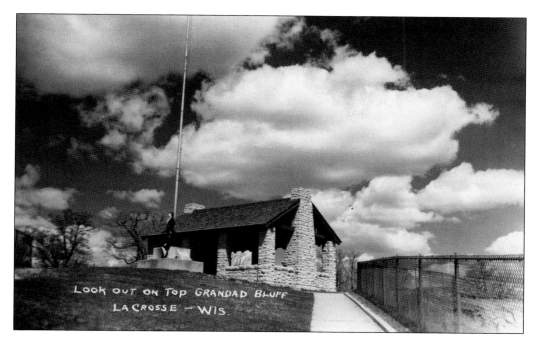

**GRANDAD BLUFF, SHELTER.** The shelter atop Grandad Bluff, built in 1938 with native stone harvested from the very bluff it sits on, was Works Progress Administration project No. 5466. It cost a total of $11,500 to construct the 22-by-29-foot building. Originally built as an open shelter, as seen in the postcard above, the building was enclosed in 1954 to better protect visitors from the elements. Consequently, the seemingly practical action made the shelter rather unattractive. During the $1.4 million 2012 remodeling of the park, the shelter was restored to its original design. Seen below is a view of Grandad Bluff from Highway 33.

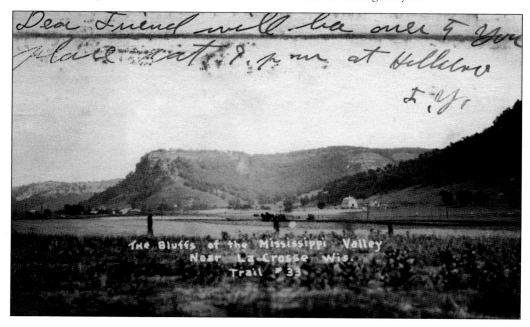

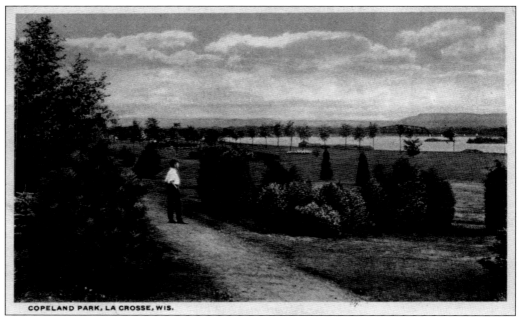

COPELAND PARK, LA CROSSE, WIS.

**COPELAND PARK, NORTH SIDE PARK.** Located along the shore of the Black River and built on a former sawmill site, Copeland Park was the first city park on La Crosse's North Side. Frederick Copeland, owner of the La Crosse Lumber Company and mayor of La Crosse from 1891 to 1892, donated the inaugural acres. Much like in Riverside Park, fill was dredged from the river to create more acreage and also to cover refuse leftover from the sawmills. Copeland Park opened to the public in 1909, although the official grand opening, which over 5,000 people attended, was not until July 1911. A 1930 steam locomotive and an 1883 caboose have been exhibited at Copeland Park since 1963. The park also houses the ball field for the La Crosse Loggers baseball team.

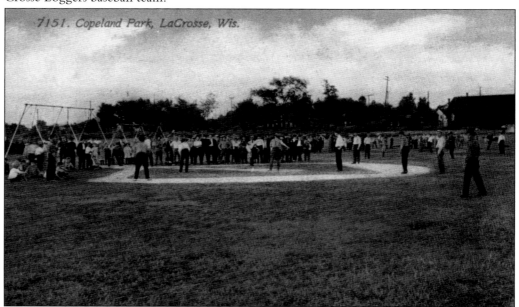

7151. Copeland Park, LaCrosse, Wis.

**HOOD PARK.** Renamed Poage Park in 2013, this park, located between Hood and Adams Streets, was originally known as the Adams Street Playground. People started referring to it as Hood Park sometime around 1924. The park was renamed in honor of George Coleman Poage, who resided in La Crosse from the age of four in 1884 until his graduation as the salutatorian from La Crosse High School in 1899. After high school, Poage became the first black athlete to run track for the University of Wisconsin, and he was the first African American to medal in a modern Olympiad in 1904. The land for the park was purchased from the Michel Brewing Company in 1909 for $3,900 in order to fulfill part of the park plan created by John Nolen. This park is only one acre in size, but it was mindfully designed with a large open area for baseball in the summer and ice-skating in the winter.

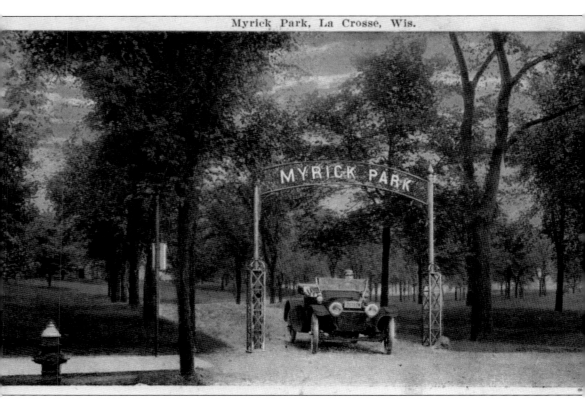

**MYRICK PARK.** In October 1873, the city acquired land known as the Turtle Mounds near the marsh and just east of Oak Grove Cemetery. The name was a reference to the animal-shaped effigy mounds built on the site by Native Americans thousands of years ago. This land eventually adopted the name Lake Park, assumedly a reference to the marsh. In 1903, a group of citizens who had added a marker to the park identifying the effigy mounds advocated changing its name to Mound Park in response to a city resolution mandating an official name for every city park. City alderman N. Bacheller instead suggested that the park be renamed after the first settler of European ancestry in La Crosse, Nathan Myrick. Bacheller's suggestion won out, and a large celebration on July 31, 1904, officially marked the name change to Myrick Park.

**MYRICK PARK, SHELTERS.** In this postcard, vaguely seen through the trees atop the knoll near the entrance to the park, is the original Myrick Park shelter. It was a pine structure built around 1870. It was previously used as an exhibition building for the La Crosse County Fair held in Myrick Park until 1890. On the eve of its destruction, a 1940 *La Crosse Tribune* article reports, "The pavilion is one of the oldest landmarks in the city." The writer concludes, "It is now past its period of usefulness and will be razed for a modern, brick structure. Appropriately enough, the new structure will be built on the same foundation which supported the old building and will be built on the same general construction plan." The replacement shelter was built from native limestone rock quarried from nearby Miller's Bluff as a Works Progress Administration project and still stands in the park today.

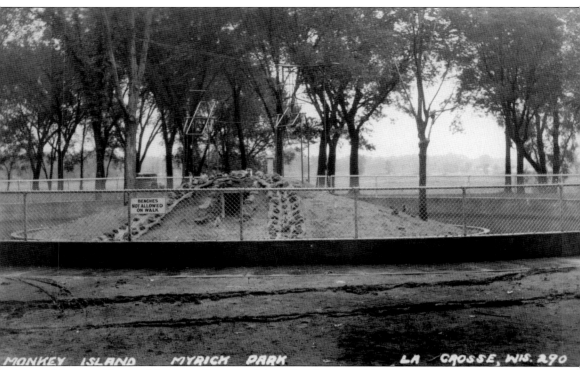

**MYRICK PARK, MONKEY ISLAND.** Many La Crosse residents fondly remember the Myrick Park Zoo, which was dedicated in August 1929 when the Veterans of Foreign Wars, Thomas Rooney Post No. 1520, presented the city with Monkey Island (seen here). Several other animal habitats and child–centered attractions were constructed in the years following the zoo's opening. Additions included a raccoon pit in 1931, wading pool in 1945, wintering quarters for zoo animals in 1952, bear den in 1954, and petting zoo in 1977. Even though the zoo has been disbanded, the miniature 1939 Tudor-style stone house built in the middle of the duck pond is still found in the park. The now defunct EcoPark, whose main building opened in 2009, replaced the zoo with the goal to move away from exotic and caged animals, instead focusing on the area's natural wildlife.

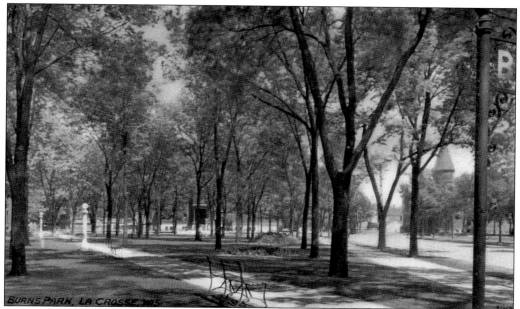

BURNS PARK, LA CROSSE WIS.

## BURNS PARK (MAIN STREET PARK).

Plotted around the year 1852, the oldest park in La Crosse is a half block off Main Street and was officially named Burns Park in 1903. It contains two diagonal sidewalks, benches, and shade trees. The name honors Timothy Burns, one of La Crosse's earliest citizens and lieutenant governor of Wisconsin from 1851 to 1853. The postcard above shows the park around 1912. Seen through the trees in the background are the entrance to the original La Crosse High School (middle) and the La Crosse Public Library (the building with the tall tower to the right). Note the big iron *B* on a post in the foreground to the right. The image at right is of a Christmas tree displayed in Burns Park in 1913.

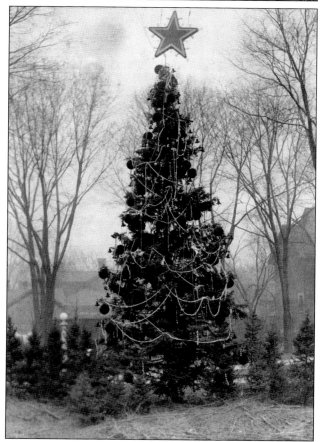

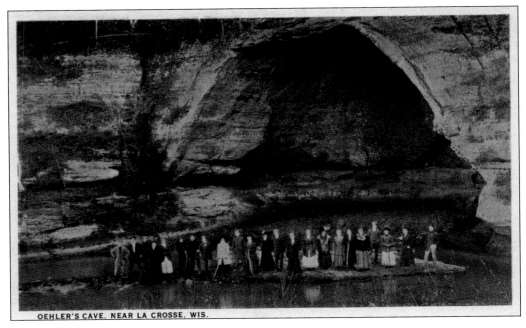

OEHLER'S CAVE, NEAR LA CROSSE, WIS.

**OEHLER'S CAVE PARK.** Six miles south of the city in Mormon Coulee, two German immigrant brothers established a private park at their flour mill. Valentine and Gottfried Oehler settled in La Crosse in 1855. Among other things, the park contained a cave, creek, artesian well, and millpond. Starting around the 1880s, city dwellers began venturing out to the countryside to enjoy the park. In 1907, the Oehler family built the park-goers a pavilion, which hosted suppers, bands, camping, and dancing. Above, a group of visitors stands in front of Oehler's Cave. The 1918 sender, Walter, writes to Marie Gerring of Chicago that they "are visiting here for a day." Below, another sizable group poses near the stone dam.

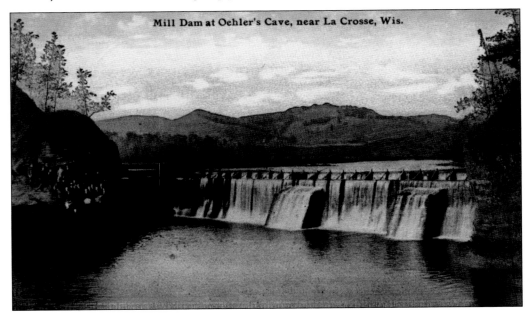

Mill Dam at Oehler's Cave, near La Crosse, Wis.

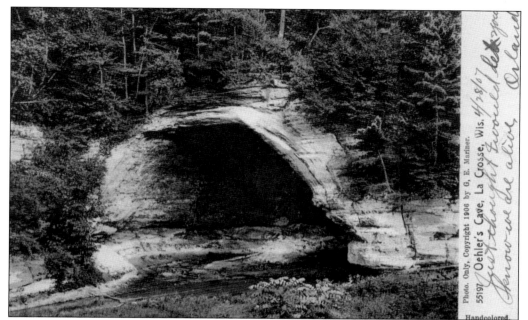

**OEHLER'S CAVE.** Located on Mormon Creek, this cave is just south of the stone dam that the Oehler brothers constructed in 1857 along with their first mill. The Oehlers' countryside park provided respite from the humid summers. Visitors enjoyed the cool water in the creek and the cave interior that feels almost air-conditioned. A bend in the creek naturally carved out the cave formation through erosion. Amazingly, much of the Oehler Mill complex still survives, including a stone flour mill built in 1862 and two Italianate brick houses built in the 1880s. The site was added to the National Register of Historic Places in 2013 because it is significant as a rare example of early rural flour milling.

ROAD TO OEHLER'S, LA CROSSE, WISCONSIN

309. V. O. HAMMON PUBLISHING CO. MINNEAPOLIS, MINN.

55196 "Oehler's Creek", La Crosse, Wis. *Here's another for our book - got here O.K. Ovie* Handcolored.

**OEHLER'S CREEK.** Oehler Mill was such a popular destination and landmark that sometimes the nearby creek was referred to as Oehler's, even though its official name is Mormon Creek. Mormon Coulee and Mormon Creek are so named because a group of Mormons settled in that area in 1844. That group of 160 Mormons constructed a log-cabin city on the then future Oehler Mill site in hopes of establishing a permanent settlement. Much like the Oehlers, the Mormon group probably chose the site because of its potential to power a mill. The combination of a tough winter, poor treatment by local residents, and the assassination of Mormon founder Joseph Smith in Illinois in 1844 resulted in this group abandoning the settlement near La Crosse.

55200 Oehler's Mill Dam, La Crosse, Wis. *June 5, '07 Will write soon lots of love - from Sophia* Handcolored.

# *Two*

# A City at Work

Nathan Myrick's trade in fur and other goods with local Native Americans in the 1840s was the first business established in La Crosse. The commerce that Myrick initiated dwindled due to federal government policy removing Ho-Chunk people from the area. The economic focus of the city then shifted to harvesting lumber.

From the 1850s until about 1900, a prosperous lumber and sawmill industry was at the forefront of La Crosse's economy. A flourish of steamboats and later railroad traffic brought in thousands of settlers seeking employment opportunities. After a sudden and dramatic decline of lumbering around the year 1900, the expansion of a unique and diversified manufacturing industry in La Crosse reinvigorated employment prospects. In 1904, the *Wisconsin Banker* reported the following on the economic situation in La Crosse:

> While the lumber interests were for many years the industrial support of the city, these have ceased to be an important factor, and in their place have come varied industries, all on firm financial standing, and many of them employers of a large force of men and women. La Crosse has now thriving manufacturers of boots and shoes, sash, doors, blinds, plows, agricultural implements, boilers and heavy machinery; extensive carriage works, rubber mills, cracker and knitting factories, etc., large flour mills, pearl button factories, steel and corrugated roofing works, woolen mills, a large tannery, mammoth cooperages, five large breweries, affording a market for 150,000 bushels of barley and 1,000,000 pounds of hops per annum; extensive cigar manufactories and various other industries.

Over the years, La Crosse has manufactured a number of nationally prominent products. Moreover, successful industrial and agriculture sectors fueled the development of the city's specialized retail and service businesses.

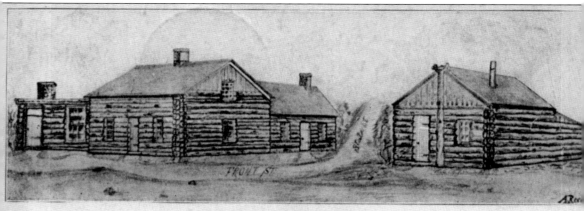

**The First Building, 1842, La Crosse, Wis.**

*will send this for your birthday, and you can see how La Crosse used to look. Alice.*

**NATHAN MYRICK, CABIN.** Postmarked 1907, this illustration is a sketch Nathan Myrick commissioned of his 16-by-20-foot trading cabin, built in February 1842 (right), and his 20-by-30-foot house, built in summer 1842 and shown here with its 1844 addition (left). These structures were located near what later became Front and State Streets. The La Crosse County Historical Society holds the original sketch in its collection. Born in New York, Myrick moved west to seek fortune. He was just 19 years old when he settled in La Crosse to launch a trading business on the frontier. Myrick left La Crosse in 1848, establishing residency in St. Paul, Minnesota. When he left, only about eight houses existed in La Crosse. Myrick remained in St. Paul until his death in 1903.

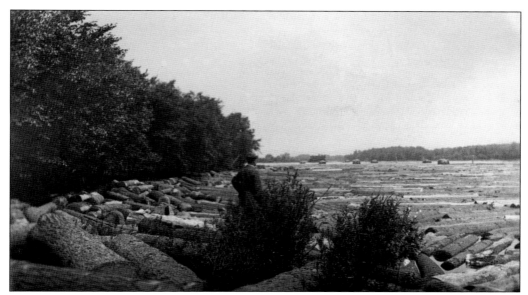

**BLACK RIVER, LOGS, JUNE 1890.** The impact of lumbering on the early growth of La Crosse cannot be underestimated. Lumbering made up 60 percent of the industrial payroll in 1880. Being favorably situated at the junction of the Mississippi, Black, and La Crosse Rivers meant that logs could easily be floated downstream to La Crosse's sawmills.

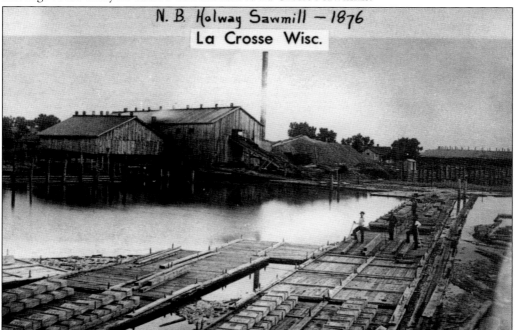

**HOLWAY SAWMILL, 1876.** There were over 30 sawmills in operation between 1850 and 1910 in La Crosse and neighboring Onalaska. The Holway Sawmill was on the east bank of the Black River. The mill operated two steam-driven circular saws and had a capacity of 18 million feet of lumber, seven million shingles, and three million lath a year. On November 11, 1903, a fire destroyed the mill.

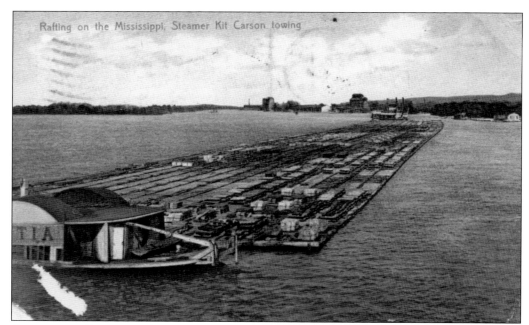

Rafting on the Mississippi, Steamer Kit Carson towing

**STEAMBOAT RAFTERS.** Beginning as early as the 1860s, rafts of logs and cut lumber were assembled and sent from La Crosse sawmills down the Mississippi to other markets. Specialized steamboats called raft boats or rafters guided these logs downstream. Some rafts were so large that they needed a bow boat lashed sideways at the head of the raft to help guide it around the bends of the river. The use of rafters began to decline in the 1890s as the mills began shipping more of their product via rail. In the above view, the bow boat *Scotia* is helping the *Kit Carson* pull away from La Crosse with a raft of cut lumber. In the postcard below, the stern-wheeler *Glenmont* is towing a log raft at La Crosse with an unidentified bow boat at the head.

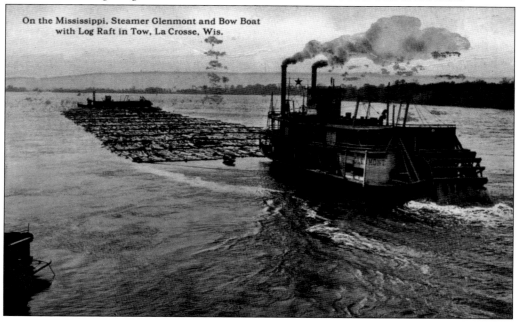

On the Mississippi, Steamer Glenmont and Bow Boat with Log Raft in Tow, La Crosse, Wis.

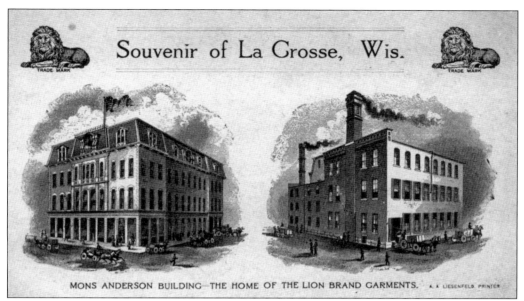

Souvenir of La Crosse, Wis.

MONS ANDERSON BUILDING—THE HOME OF THE LION BRAND GARMENTS.   A. L. LIESENFELD, PRINTER

**MONS ANDERSON COMPANY.** Norwegian immigrant Mons Anderson, nicknamed the Merchant Prince, established his wholesale, clothing, and retail dry goods business in 1852. The flagship store was built between 1865 and 1870 at Second and Main Streets. Damaged in the 1965 flood, it was later demolished. Anderson manufactured his own Lion Brand of clothing in the upper stories of the retail store. The lion, seen in the top corners of this postcard, was Anderson's trademark.

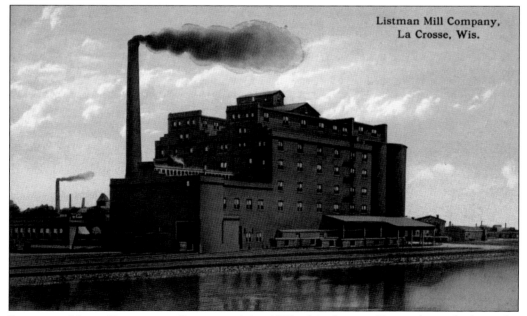

Listman Mill Company,
La Crosse, Wis.

**LISTMAN MILL COMPANY.** Constructed in 1879, this flour mill was located along the Mississippi River on Front Street. One of its trademark products was "Marvel Flour – Milled on the Maxim of Most Bread with Least Flour." A fire on October 28, 1935, destroyed much of the original building complex pictured on this postcard.

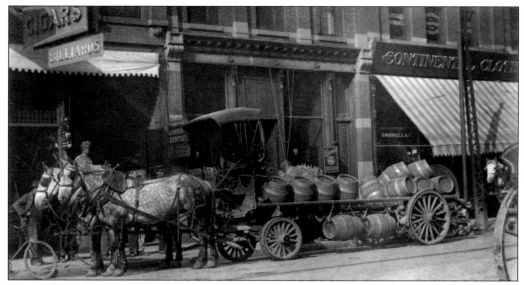

**GUND BREWERY DELIVERY, C. 1908.** A horse-drawn wagon delivers beer from the Gund Brewery to a business on Fourth Street. John Gund founded his first brewery in La Crosse in 1854 at Front and Division Streets. He sold that log cabin brewery in 1858 and, along with fellow German immigrant Gottlieb Heileman, launched the City Brewery. Gund sold his City Brewery shares in 1872.

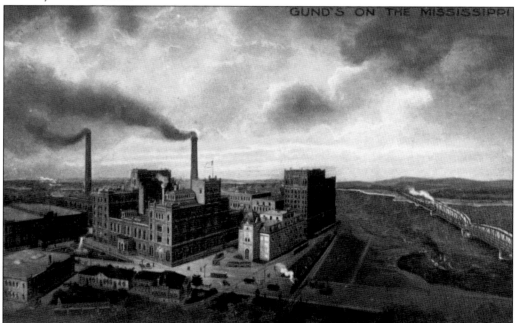

**GUND BREWERY ON THE MISSISSIPPI RIVER.** Built on the 2100 block of South Avenue, the Gund Brewery filed for incorporation in 1880. A disastrous fire in 1897 destroyed several buildings on the five-acre complex. Gund rebuilt, and his business grew to become the largest brewery in Wisconsin outside of Milwaukee, eventually encompassing 15 acres. Mailed in 1917, this German-printed postcard shows the reconstructed brewery.

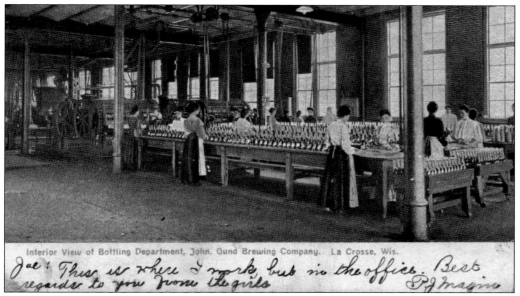

Interior View of Bottling Department, John. Gund Brewing Company. La Crosse, Wis.

*Joe: This is where I work, but in the office. Best regards to you from the girls. P.J. Magin*

**GUND'S BOTTLING DEPARTMENT.** The Gund Brewery employed around 450 workers when this postcard traveled through the mail in 1908. Women made up a substantial portion of the employees, many of whom worked in the bottling-line and in the office, as ascertained from the postcard image and the sender's message: "This is where I work but in the office. Best regards to you from the girls. P.J. Magin."

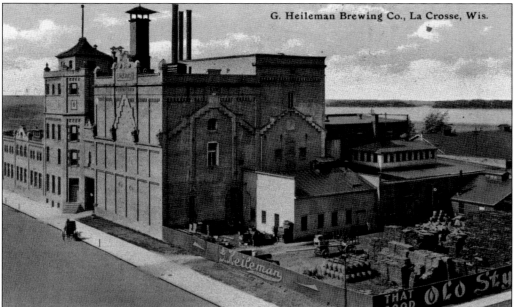

G. Heileman Brewing Co., La Crosse, Wis.

**HEILEMAN BREWING.** This company traces its roots to the City Brewery, founded in 1858 by John Gund and Gottlieb Heileman. When Gund left the City Brewery operation in 1872, Heileman continued to run the company but under his own name. Upon his death in 1878, his widow Johanna Heileman took over operations. When the brewery incorporated in 1890, she became one of the first women in the nation to head a major corporation.

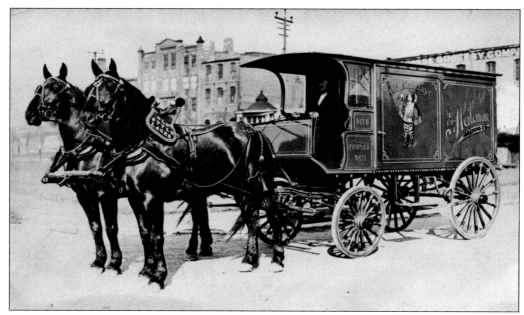

**HEILEMAN DELIVERY, C. 1908.** Pictured here is a matched set of horses fitted with gleaming harnesses ready to pull an ornamental Heileman Brewing Company delivery wagon. The side of the wagon proudly advertises the brewery's most well-known beer, Old Style Lager. Although still in production today, Old Style Lager is no longer made in La Crosse.

**LA CROSSE PLOW COMPANY.** This company was incorporated in 1893. Initially, it specialized in the manufacture of walking plows but later added riding plows and other farm equipment. The company was sold to Allis Chalmers in 1929. At its peak, the plant employed over 1,500 workers and had the second-largest tax valuation in La Crosse. The plant closed in 1969.

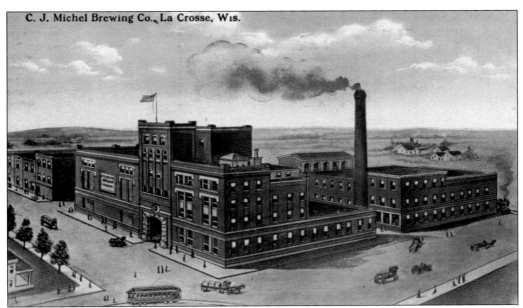

C. J. Michel Brewing Co., La Crosse, Wis.

**MICHEL BREWING, C. 1915.** Charles and John Michel started brewing beer in La Crosse in 1857. They purchased a majority of the needed hops from nearby Bangor, Wisconsin. The pictured brewing complex was constructed in 1907 at 710 Third Street South. Michel's most famous beer was Elfenbrau. Following Prohibition, Peerless Beer, a brand they purchased from the Gund Brewery, became their most popular beer. The company stopped producing beer in 1955, and the Dahl Motor Company later bought the property. Despite the best efforts of the Preservation Alliance of La Crosse, the Wisconsin Trust for Historic Preservation, and local history aficionados who circulated a petition that garnered a thousand signatures in favor of saving the landmark, the brewery was demolished in June 1997.

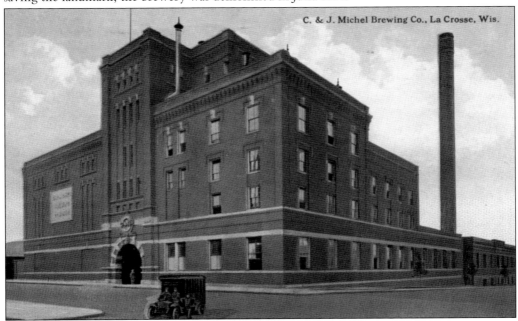

C. & J. Michel Brewing Co., La Crosse, Wis.

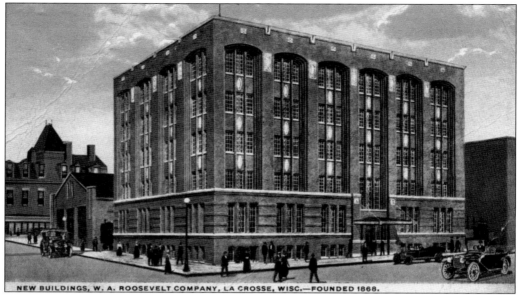

NEW BUILDINGS, W. A. ROOSEVELT COMPANY, LA CROSSE, WISC.—FOUNDED 1868.

**W.A. ROOSEVELT BUILDING, C. 1917.** Engineer and steamboat captain William Roosevelt founded this company in 1868. For the company's 50th anniversary, a new building was constructed at the corner of Front and Vine Streets. Flooding in 1965 damaged the building, and the company decided to relocate in 1978. The building is now the home of Trust Point, a financial services company.

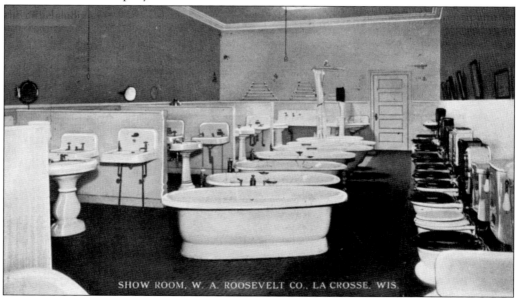

SHOW ROOM, W. A. ROOSEVELT CO. LA CROSSE. WIS.

**W.A. ROOSEVELT SHOWROOM, 1915.** In its early years, the W.A. Roosevelt Company specialized in steamboat equipment, carbon lamps, and plumbing supplies, including bathroom fixtures, as seen in this view of the showroom. The company expanded, adding an electrical department in 1916, a radio department in 1922, and a refrigeration unit in 1938. Today, the company continues to serve plumbing, electrical, heating, ventilation, and air-conditioning customers throughout the upper Midwest.

**NATIONAL BANK OF LA CROSSE.** This bank's absorption of the German American Bank sparked the construction of this 1905 building. Located at 114 Fourth Street North near the Stoddard Hotel, the bank conducted business here until 1957. The building's front columns, made of Indiana limestone, weighed an estimated five tons each. When the building was razed in 1960, Swanson's Heavy Moving carefully removed the columns in hopes for reuse.

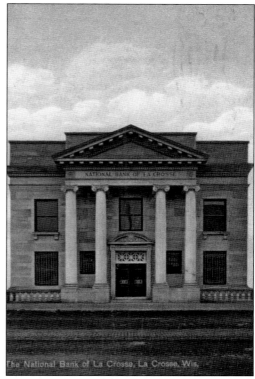

**NATIONAL BANK EMPLOYEES, 1909.** The first president of the National Bank of La Crosse, established in 1877, was Gideon Hixon. Best known for his involvement in the lumber industry, Hixon served as bank president until his death in 1892. Seen here are the 1909 employees standing in front of the bank, including Charles Bonneville who mailed this postcard to his sister.

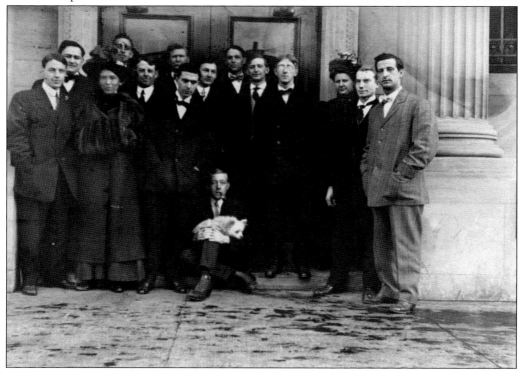

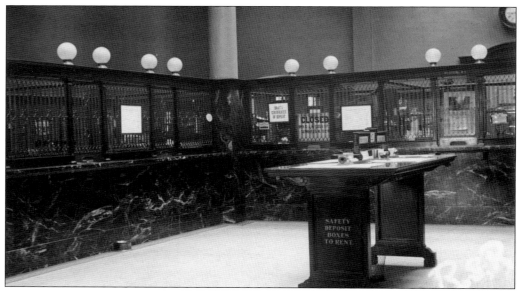

**NATIONAL BANK INTERIOR, 1910.** The name of this institution has changed several times. The first moniker, the La Crosse National Bank, was used from 1877 to 1896. Upon expiration of the bank's charter, the directors liquidated the old bank and reorganized as the National Bank of La Crosse. They retained that name until 1956 and then changed it to the First National Bank of La Crosse.

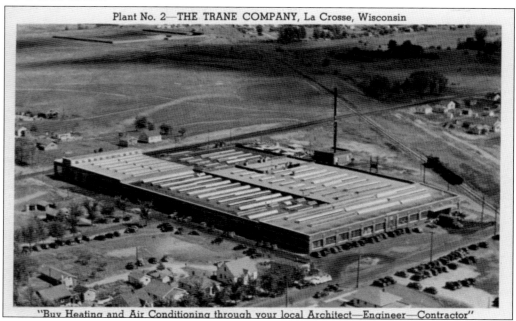

**TRANE COMPANY.** In 1885, James Trane founded this company as a plumbing and heating shop. His son Reuben brought the company to national prominence with his work on the convector radiator in the 1920s. After that, the company grew rapidly specializing in industrial heating and air-conditioning. Construction began on Trane Plant No. 2, pictured here, on East Avenue in 1930.

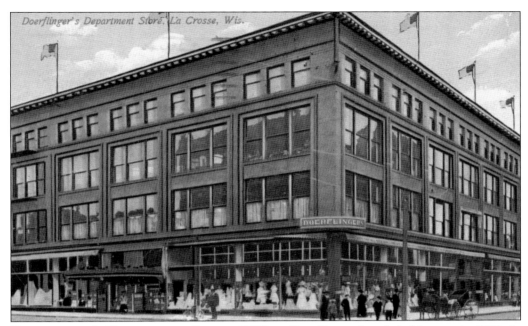

**DOERFLINGER'S DEPARTMENT STORE.** William Doerflinger founded this store in 1881. In an article published on January 3, 1954, the *La Crosse Tribune* refers to this store as "the pillar of the local mercantile world." The store suffered a disastrous fire in 1903. Following the fire, it reopened in a new building at the prominent intersection of Fourth and Main Streets, and it remained there for the next 80 years, closing in 1984.

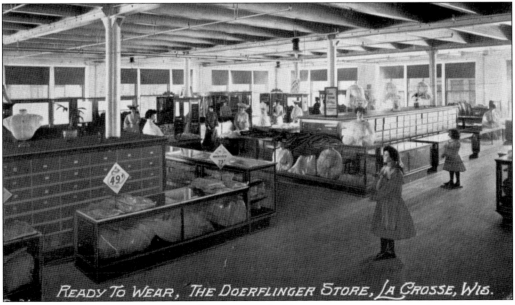

**DOERFLINGER'S CLOTHING.** Ready-to-wear clothing was one of the products that made Doerflinger's so popular. Besides men's, women's, and children's clothing, other departments in the store included furniture, housewares, glassware, china, and domestics.

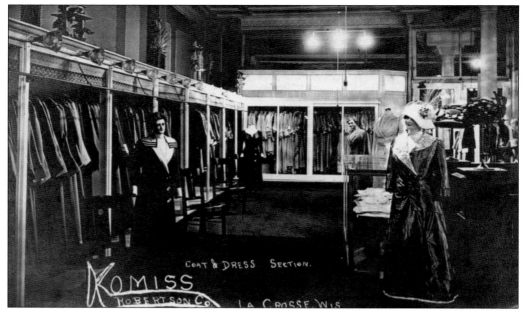

**KOMISS AND COMPANY.** Located next to Doerflinger's on Main Street, Komiss was a specialized ladies' clothing store. The high-end coats, suits, dresses, and furs found there starkly contrasted with the ready-to-wear clothing found next door. This c. 1912 interior shot shows the store's impressive array of electric lighting, which helped to display the latest fashions.

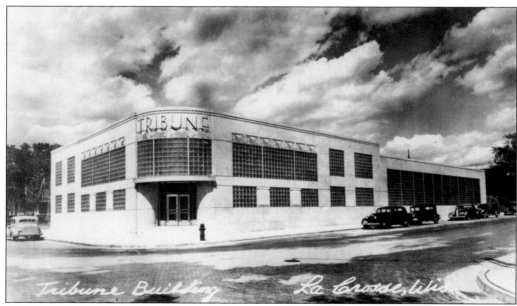

*LA CROSSE TRIBUNE.* Since its beginning in 1904, the *La Crosse Tribune* newspaper has occupied four different buildings in downtown La Crosse. This Art Deco building with a rounded front corner and glass-block windows was its third home. Located at Fourth and Cass Streets, this spot was occupied by the *Tribune* for 35 years, from 1938 until 1974. The *Tribune's* current home is at 401 Third Street North.

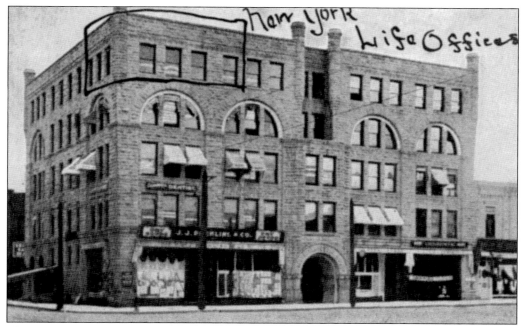

**McMillan Building and State Bank.** In 1888, Alexander McMillan built the structure seen above. The building is located on the corner of Fourth and Main Streets. In 1913, the State Bank of La Crosse moved into the McMillan Building, where it still operates, from its previous location at 311 Main Street. Alexander's brother Duncan McMillan was president of that bank from 1883 to 1896. Seen below is the lobby of the State Bank shortly after its 1913 relocation. In 1957, the McMillan Building was significantly altered. The exterior was refaced with Minnesota granite and bronze trim. In 1997, the State Bank undertook a $1.5 million historic renovation of the five-story building. This major investment was an impetus for further downtown revitalization, sparking other private businesses to invest in similar undertakings.

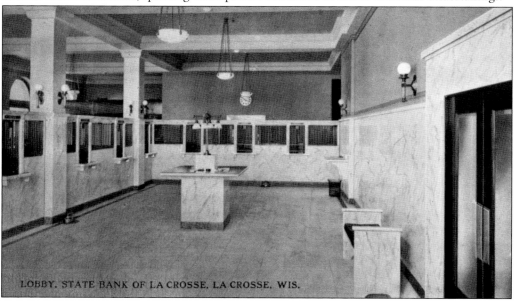

LOBBY, STATE BANK OF LA CROSSE. LA CROSSE. WIS.

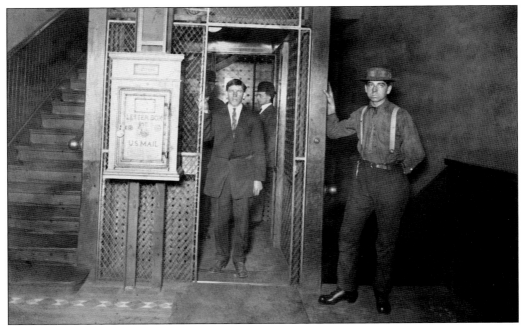

**STATE BANK, C. 1913.** Pictured above, elevator operator Clyde Jones (on right wearing hat and suspenders) helps riders reach their desired destination. This 100–plus–year–old elevator is still in service in the McMillan Building, complete with an elevator operator. It currently makes around 200 trips per day. It is the only manually operated elevator in the city. When speaking of manually operated elevators in 2006, operator Bill Culver said that people "are surprised to see they still exist" and often "comment on how fast they are, compared to the automatic ones." Seen below is the bank's cash vault. The left side shows the vault door while shut, and the right side shows the door open, revealing the interior of the vault.

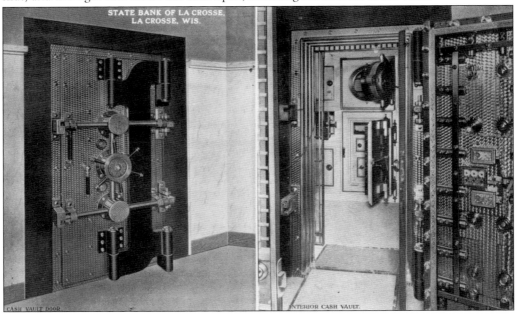

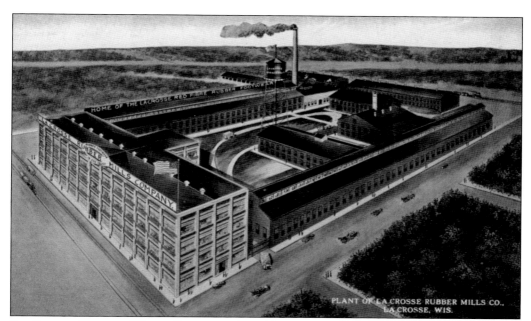

**LA CROSSE RUBBER MILLS COMPANY.** Local businessmen Albert Hirshheimer and Michael Funk founded this company in 1897. In its first decade, the company manufactured rainwear but switched to rubber footwear in 1907. The factory was originally a wooden structure located on St. Andrew Street in north La Crosse. Over the next several decades, the large complex of buildings, seen in this overhead view, was constructed.

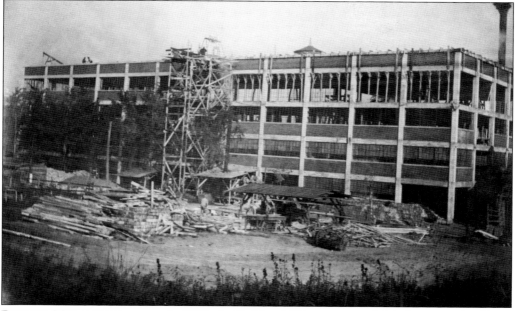

**RUBBER MILLS EXPANSION.** In 1913, the Rubber Mills constructed this four-story building. Other additions were made in 1916 and 1919. In the 1920s, the factory could make around 20,000 pairs of shoes a day, and it employed about 1,500 people. The La Crosse Rubber Mills grew to become the nation's largest domestic manufacturer of protective rubber footwear.

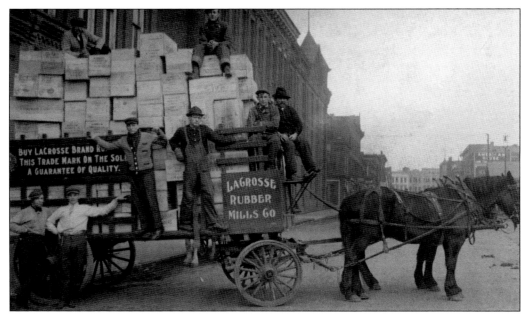

**RUBBER MILLS DELIVERY, C. 1912.** Seen here is a horse-drawn delivery wagon for the Rubber Mills on the 200 block of Pearl Street. That particular block of Pearl Street was the red-light district during this time. The two men standing on the wagon are Fred Kolb (left) and Bill "Lefty" Blank. The postcard writer identifies Blank as "my old pitcher for Summit Store Base Ball Team, 1912."

**RUBBER MILLS, GROWTH AND DECLINE.** Under new ownership, the Rubber Mills became La Crosse Footwear in 1982. The business remained one of La Crosse's largest employers into the 1990s. Industry consolidation and international competition, however, led to downsizing and the eventual sale of the factory in 2001. Much of the original factory complex still stands and now houses a number of start-up businesses, including the Pearl Street Brewery.

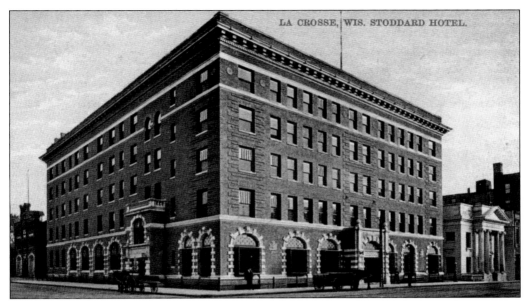

**STODDARD HOTEL, BUILT 1904.** This hotel was named for La Crosse's first mayor, Thomas Stoddard, and was located at Fourth and State Streets. It was the premiere hotel in downtown La Crosse. In 1929, John Elliott became the manager and later the owner. Elliot sold the business in 1972. Although there were several proposals for renovating the building, including remodeling it into apartments, it was torn down in 1982.

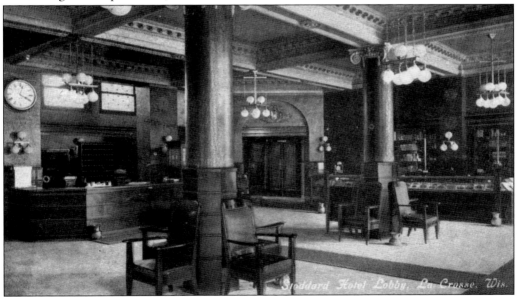

**STODDARD HOTEL, INTERIOR.** The main lobby of the Stoddard Hotel glistened with marble floors, oak woodwork, and bronze grillwork. There were 107 bedrooms for guests and 14 rooms for servants. Each room had its own telephone, which was a novelty in 1904. The hotel was remodeled in the 1930s and featured the Crystal Room for dining and dancing and the Wisconsin Room, which had a 30-foot semicircular bar and murals of de Soto discovering the Mississippi River.

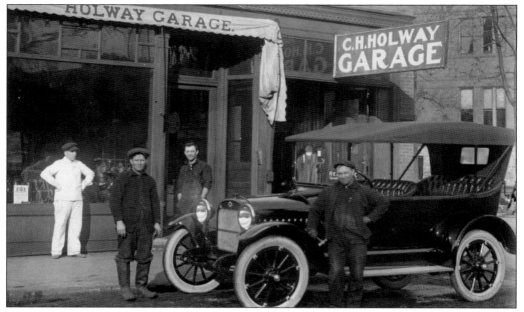

**HOLWAY GARAGE, C. 1915.** Increased automobile ownership in the early 20th century created a corresponding need for mechanics and repair shops. Located at 429 State Street, the Holway Garage met that need. It advertised itself in the city directory between 1913 and 1919 as the "Best equipped garage and repair shop in Western Wisconsin."

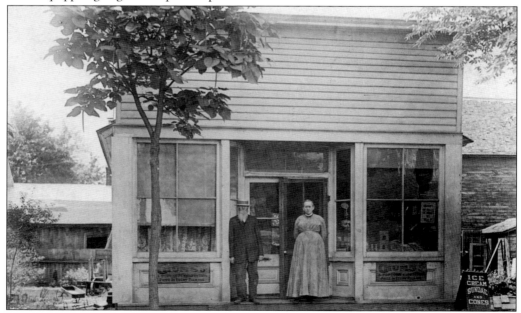

**CONFECTIONERY, NORTH SIDE, C. 1905.** Clark Watson Smith and his wife, Mary McKinney Smith, stand outside their confectionery located at 1120 Logan Street. The couple moved to La Crosse in 1871. Clark was a veteran of the Civil War. The signs on the building advertise ice cream, as well as a popcorn treat called Chums. Greatly altered in appearance, this building still stands and serves as a gathering place for local veterans.

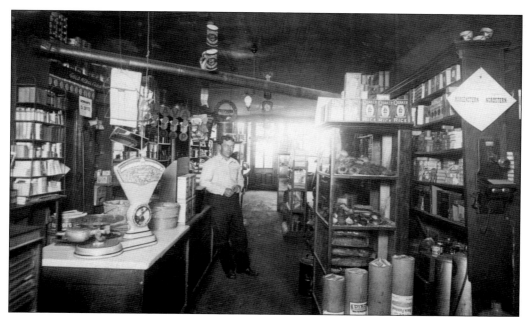

**IKERT GROCERY STORE.** The 1915 city directory lists 71 retail groceries serving La Crosse. The Ikert grocery store was located at 2506 Mormon Coulee Road and was also the residence of owners Ignatz, Fred, and Laura Ikert. Fred is pictured here inside the store along with some familiar brands such as Quaker Puffed Rice, Lava soap, and Gold Medal Flour.

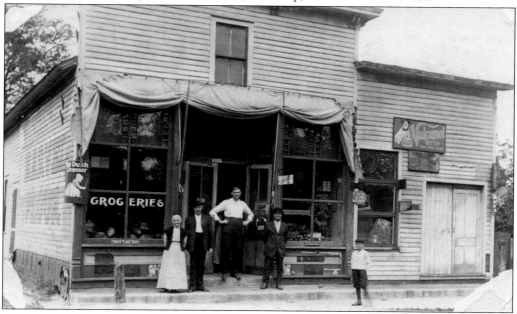

**NORTH SIDE GROCERY STORE.** The 1924 city directory lists 119 grocery stores in the city, an increase of 48 establishments from 1915, just nine years before. The directory indicates that Joseph Shirkalla was the proprietor of this store located at 1101 Liberty Street. Liberty Street gained its name due to patriotic fervor and anti-German sentiment during World War I. Previously, it was named Berlin Street.

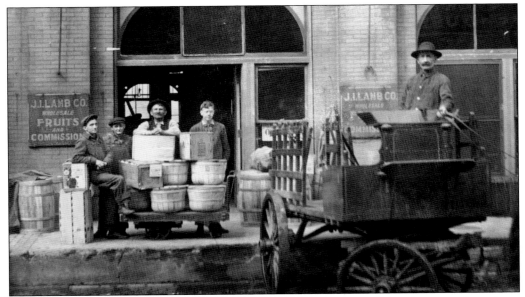

**J.I. LAMB FRUIT COMPANY, C. 1913.** This fruit wholesaler exemplifies the type of merchant that once thrived on the waterfront, utilizing Front Street's easy access to the railroads and the Mississippi River. Damage from the 1965 flood resulted in this building and many others in a similar condition being torn down in the 1970s and 1980s downtown urban renewal Harbor View Project.

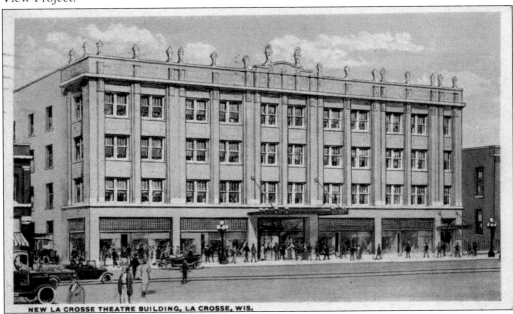

NEW LA CROSSE THEATRE BUILDING, LA CROSSE, WIS.

**RIVOLI THEATRE, BUILT 1920.** Often referred to as movie palaces, movie theaters of yesteryear, like the Rivoli at 117 Fourth Street North, were elaborately decorated. When opened, the Rivoli showcased velvety red seats, castle turrets, iron balconies, a twinkling-star ceiling, tuxedo-clad attendants, and a $20,000 organ used to provide background music for silent movies. The organ was sold to an Ohio church in the 1940s.

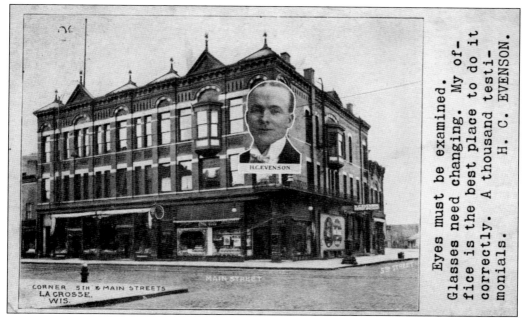

**EYESIGHT SPECIALIST, C. 1910.** Dr. H.C. Evenson certainly believed in the power of advertising. In addition to the appeal on the front, the back of the postcard contains further advice stating, "Don't ruin your eyes with poor glasses. Have them correct." It concludes with the doctor's slogan, "Then you'll come to me," in all caps.

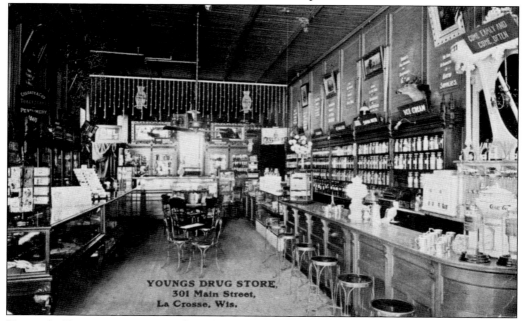

**YOUNG'S DRUGSTORE.** One of 15 druggists listed in the 1915 city directory, Young's was located on Main Street, which was apparently the place for druggists since six others were also located there. Young's had an old-time soda fountain, serving ice cream and Coca-Cola. It also sold bath supplies, soda water, cigars, and candy.

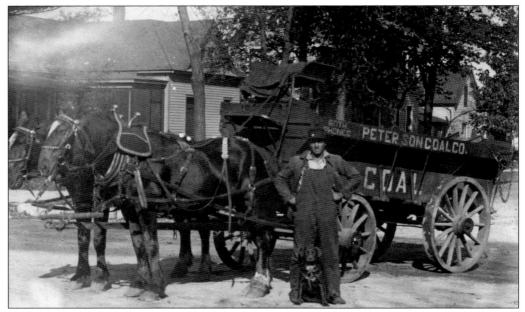

**PETERSON COAL COMPANY, C. 1913.** Seen here is a delivery wagon pulled by a matched team of horses. It was used to bring coal to homes and businesses. The deliveryman poses in front of the wagon with man's best friend at his feet. The Andrew Peterson Coal Company was located at 1650 George Street on the city's North Side.

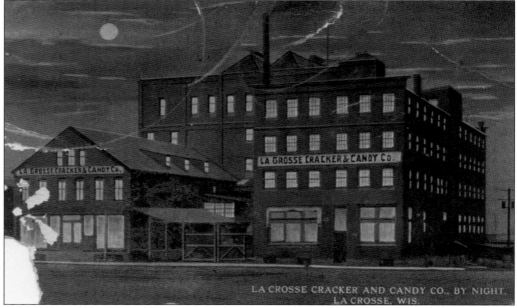

**LA CROSSE CRACKER AND CANDY COMPANY.** Founded in 1884 on Front Street, this company later moved to the 400 block of Third Street North. By 1928, it had changed its name to Montague-Fairbairn. Its brands included Samoset Biscuits and Velvo Sweets. It was one of three candy companies in La Crosse in the 1920s. The other two were Kratchwil Candy and Funke Candy, the largest of the three.

# *Three*

# CITY PEOPLE

People, not brick-and-mortar buildings, make up the character of a city. The story of ordinary life in La Crosse is vibrant and rich. It includes Native Americans, average citizens, social organizations, personal dwellings, neighborhood streets, and everyday sights and gatherings. Daily life in La Crosse continues to thrive today as the city progressively transitions and expands.

A plethora of social organizations have served to gather the citizens of La Crosse in friendship and also to undertake community betterment projects. These social groups, to which both average citizens and well-known civic leaders belonged, capitalized on their numbers, influential colleagues, and organizational structure to improve the overall quality of life of their members and the city as a whole. These organizations, along with governmental entities, had the power, funds, foresight, and expertise to identify, address, and solve common problems that are often too difficult for individuals to tackle on their own. Many of these groups still exist today. Others are gone but fondly remembered, and some groups are almost forgotten.

Images of everyday persons and groups of the past give those in the present a better understanding of life in the community. These pictures often reveal what was most important to people, as having a photograph taken was a special occasion. People commonly posed with treasured belongings, persons, or places. The pages that follow are a partial look into the story of La Crosse's citizenry.

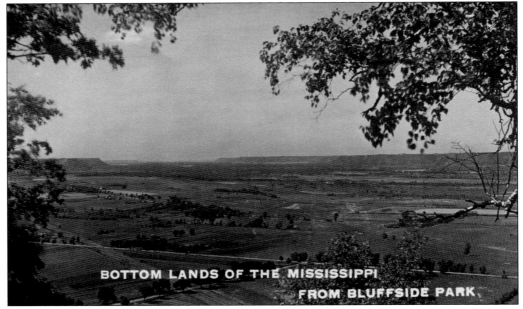

BOTTOM LANDS OF THE MISSISSIPPI
FROM BLUFFSIDE PARK

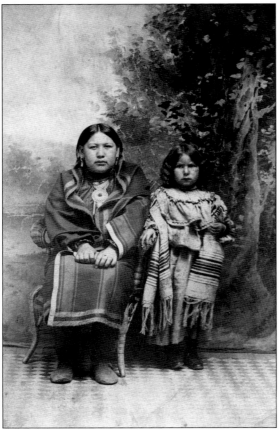

**FIRST PEOPLES.** This postcard shows an aerial view of La Crosse, an area that Native Americans inhabited long before Nathan Myrick's arrival. Visible evidence of some of the area's first residents is found in Myrick Park. This is where the Late Woodland Native American culture built mounds that date between the years 700 to 1100 BCE. Members of the Ho-Chunk Nation credits this culture with being their early ancestors.

**HO-CHUNK, STUDIO PORTRAIT, C. 1908.** The predominant Native American tribe in the La Crosse region is the Ho-Chunk, whose name means "people of the big voice." Previously, they were known as the Winnebago. The federal government bestowed this name upon them, which was a bastardized version of Ouinepegi, a name that the neighboring Sauk and Fox tribes assigned to the Ho-Chunk. In 1993, the tribe's correct name was officially reinstated.

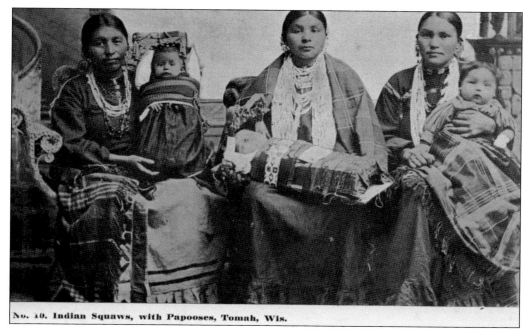

No. 10. Indian Squaws, with Papooses, Tomah, Wis.

**HO-CHUNK WOMEN, C. 1907.** Starting in 1836 under the federal government's official removal policies, the Ho-Chunk people were forced to leave Wisconsin when a series of egregious treaties ceded their lands to the federal government. In the face of deadly removal actions and the dangerous consequences of noncompliance, many Ho-Chunk repeatedly returned to their ancestral lands in Wisconsin. Between 1874 and 1881, the government finally relented to their resistance and, in an attempt to assimilate the Ho-Chunk, deeded 40-acre farmsteads to be used for single-family farming to those who refused relocation to far-off reservations. The land deeded was much less desirable than their original territory, as the best land went to white settlers. Returning Ho-Chunk settled in 16 different Wisconsin counties. After the genocidal removal attempts, Native Americans continued to endure discrimination as evidenced by the disrespectful language in these postcards in reference to Ho-Chunk women.

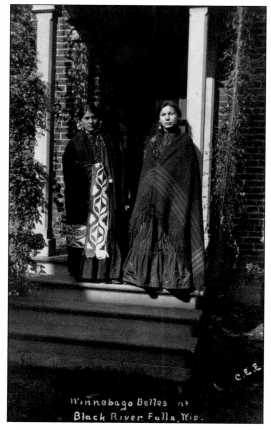

Winnebago Belles at Black River Falls, Wis.

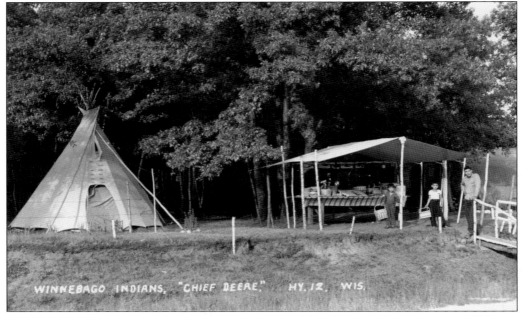

WINNEBAGO INDIANS, "CHIEF DEERE." HY. 12. WIS.

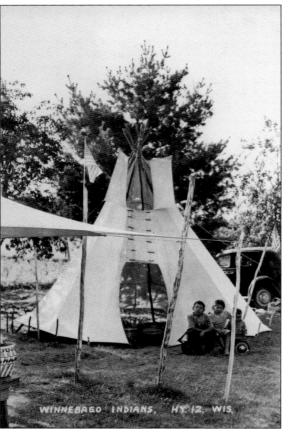

WINNEBAGO INDIANS, HY. 12. WIS.

**HO-CHUNK, BASKETRY, C. 1930.** Many in the La Crosse area remember Ho-Chunk who weaved and sold handmade baskets, such as those pictured in these two postcards, for many years downtown near Doerflinger's Department Store. The images seen here were taken somewhere along Wisconsin's Highway 12. Evidence suggests that the art of basket making was established in Wisconsin among Native Americans before those of European ancestry even arrived in the Americas. The skill has been handed down through the generations. After they experienced severe hardship at the hands of the federal government and white settlers, the sale of black ash baskets was one avenue taken by some Ho-Chunk people to supplement their income, especially during the Great Depression.

WINNEBAGO VILLAGE, BLACK RIVER FALLS, WIS.

*Did you ever see your birth plac White.*

*my own Indian*

**HO-CHUNK, HOUSING.** In the previous two postcards, note the presence of historically inaccurate Ho-Chunk housing, a teepee domicile, probably in place to cater and market to tourists. Traditionally, the Ho-Chunk constructed several different types of lodges that varied in material and size depending on the season and purpose. Occasionally, small teepees were used for short berry gathering or hunting excursions; however, a more representative traditional home would be a domed wigwam, also known as a round house or *ciiporoke*, similar to what is depicted in the image seen here. This c. 1905 image shows living quarters and a cooking tent for use in the warmer months. Note how the sides are raised for airflow. Over the years, different materials were adopted to cover lodges. Early materials included cattail mats, deer hides, and sheets of bark. This later depiction shows a canvas-covered dwelling. Charles Van Schaick of Black River Falls, Wisconsin, took this image. He avoided the stereotypical photographic representations of Native Americans, producing images not for tourists or mass consumption but rather images intended for the Ho-Chunk themselves.

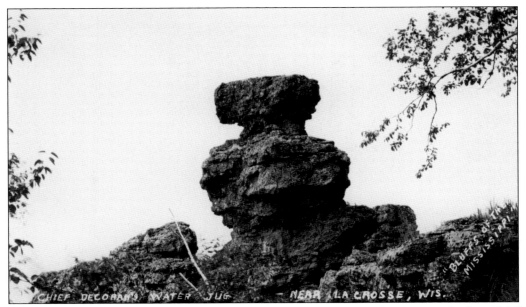

**CHIEF DECORAH.** Pictured is a rock formation near La Crosse that is named after Chief Waukon Decorah, who lived from around 1780 to 1868. Decorah was an important leader in diplomacy between the Ho-Chunk and the federal government. He traveled to Washington, DC, several times to negotiate a way to halt encroachment on Ho-Chunk land.

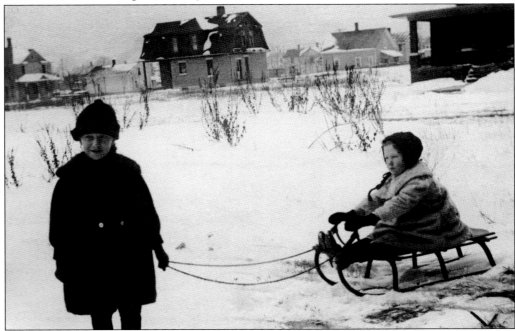

**SLEDDING, 1911.** Alberta and Dorothea Sendelbach pose near the front of their house on the 1200 block of Fourteenth Street South on December 27, 1911. According to the 1911 city directory, their father, Michael Sendelbach, was a laborer at the Vote-Berger Company, which manufactured telephones at 1801 West Avenue South.

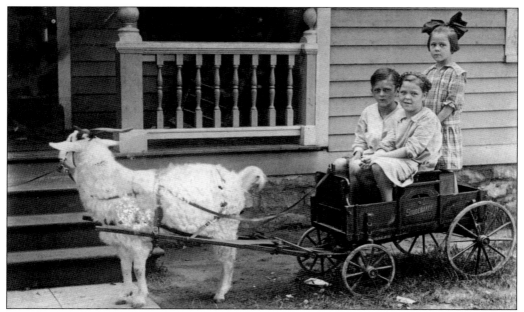

**GOAT PHOTOGRAPHER.** A number of photographs have surfaced featuring children in goat-drawn wagons. At least one mystery photographer conducted this seemingly unusual enterprise in La Crosse. However, photography featuring this subject matter was not unique to the area. Similar-looking photographs were taken throughout the nation. The wagon in the image above is a Studebaker Junior. Originally built as a scale demonstration model for dealers, it became popular as a children's toy. The frame was oak, painted green, with yellow-and-black box-shaped accent striping for trim. The 12-inch front and 18-inch rear wheels were painted red, along with the tongue. Produced from the 1900s until World War II, the wagon cost about $10 to purchase when this photograph was taken around 1912. Today, reproductions of the wagon cost around $1,000.

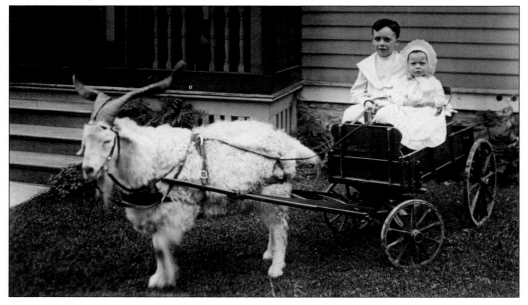

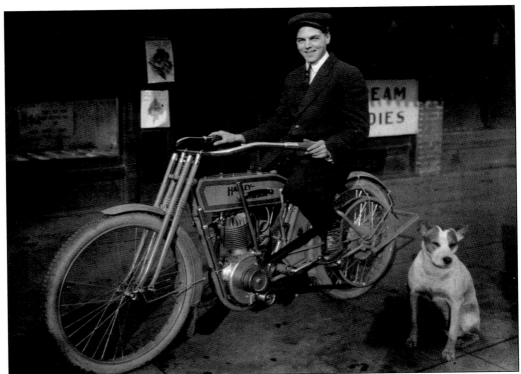

**MOTORBIKES, C. 1914.** Harley-Davidson, headquartered in Milwaukee, Wisconsin, no doubt experienced increased popularity in La Crosse due to its proximity. In the image above, a young man proudly poses with his motorcycle and his dog. In the postcard below, sender Howard C. writes, "This is a picture of dummy Fitzpatrick and his Harlem-Davy with sidecar." The suit-clad Fitzpatrick with his foot on the shifter is positioned to travel westward, away from the bluffs of La Crosse. Note his riding gloves and boots. Also, check out the elaborate-looking horn on the bike's handlebars.

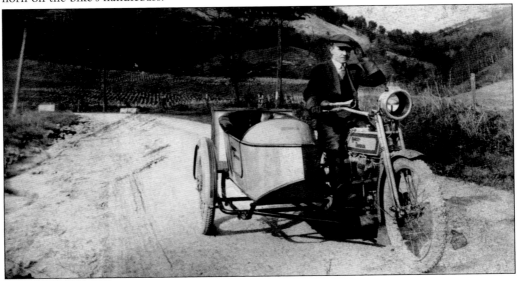

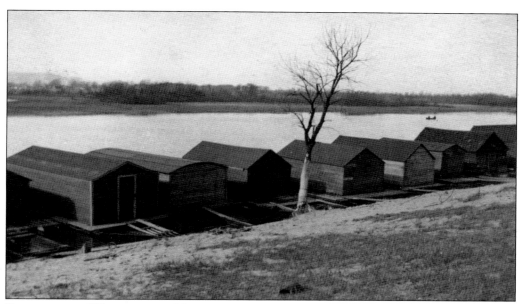

**BOATHOUSES, WATERBOUND NEIGHBORHOOD, THE 1920S.** Slowly being phased out due to environmental concerns, this boathouse neighborhood not far from the Clinton Street Bridge on La Crosse's North Side may soon be a thing of the past. These windowless and drably colored dwellings are quite a bit plainer than the current boathouses.

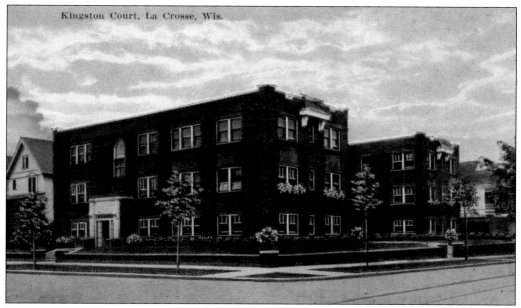

Kingston Court, La Crosse, Wis.

**KINGSTON COURT, BUILT 1924.** A slice of big-city living appeared in La Crosse when the Louis Fleischer Company of Minneapolis, Minnesota, constructed these middle-class apartments on the corner of Sixteenth and King Streets. Tenants had a choice of three-, four-, and five-room units. Also available to renters were indoor parking spaces in the nearby 10-bay garage.

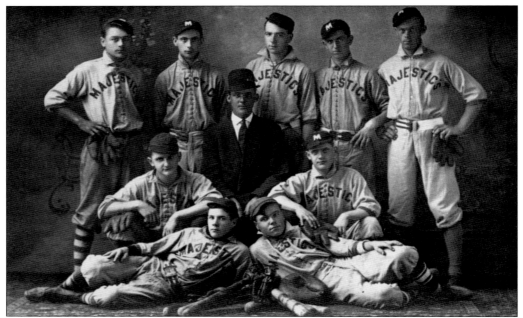

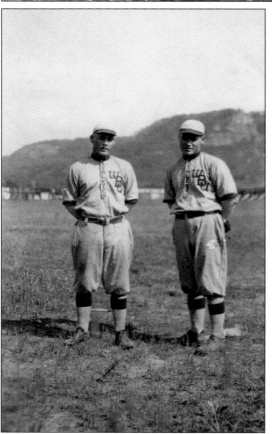

**BASEBALL.** The Majestic Theatre baseball team is seen above around 1910. This image stands out from other local baseball photographs because of the location at an indoor photography studio rather than a baseball field. It is believed that the first baseball game played in La Crosse was in the year 1853. By the 1860s, there were several organized baseball teams and a club in the city. It was not until 1893 that an official city league was formed. In 1894, the Wisconsin Business University baseball team was added to the city league. At right, twin brothers Ray (left) and Russell Lovold are pictured in their Wisconsin Business University baseball uniforms.

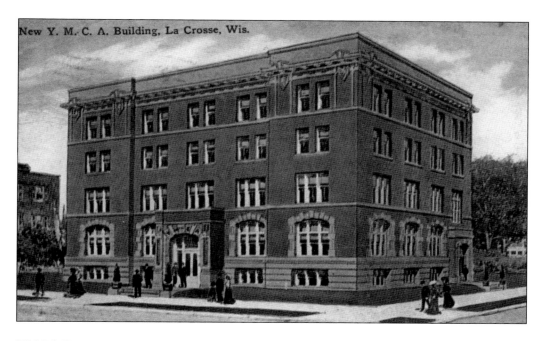

New Y. M. C. A. Building, La Crosse, Wis.

**YMCA BUILDING, BUILT 1909.** A branch of the Young Men's Christian Association opened in La Crosse in 1883. Twelve years later, in 1895, the YMCA purchased Sandia Hall off Market Square. When more space was needed, the Y constructed a building at Seventh and Main Streets, pictured here. Upon its 1909 completion, Pres. William Howard Taft, an 1878 Yale University classmate of National Bank of La Crosse president George Burton, traveled to La Crosse per Burton's invitation to dedicate the new building. The new facility cost $100,000 and contained a reading room, game room, dormitory space, sauna, gymnasium, and pool.

Y. M. C. A. La Crosse, Wis.

**George Burton House, Built 1906.** Located at 1428 Main Street, this house was owned by George Burton, president of the La Crosse National Bank. Pres. William Howard Taft spent the night in this house when he visited La Crosse in 1909 for the dedication of the new YMCA building.

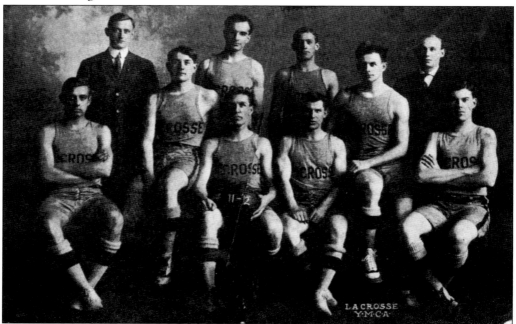

**YMCA, Basketball Team, 1911–1912.** Because there were no laundry facilities at the YMCA building, instead of washing shared athletic jerseys, basketball players sprayed them with an aerosol disinfectant. The harsh cleaning product caused the jerseys to gray and disintegrate, forcing frequent replacement.

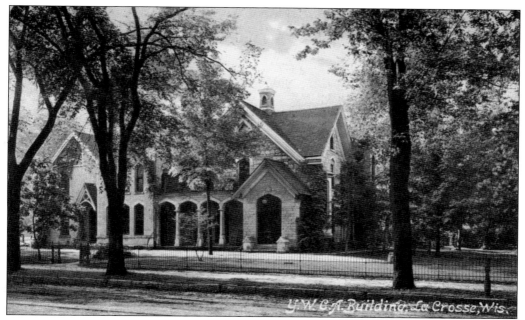

**YWCA/Mons Anderson House, Built 1854.** In 1864, Mons Anderson purchased this house from stonemason Andrew Shepard. Anderson added a massive addition in 1878, erecting the tower, west wing, and, in the back, a ballroom. After Anderson's death in 1905, the house became the home of the Young Women's Christian Association until it moved to another building in 1918.

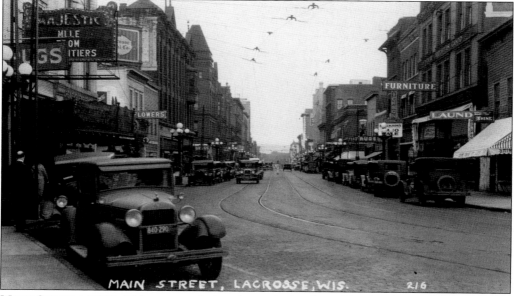

**Main Street, 1928.** This westward view shows the hustle and bustle of downtown La Crosse on the 500 block of Main Street. The Majestic Theatre is to the left, and street parking is scarce. Many citizens visit downtown for work, entertainment, shopping, and health care, but downtown is also a neighborhood where many people live.

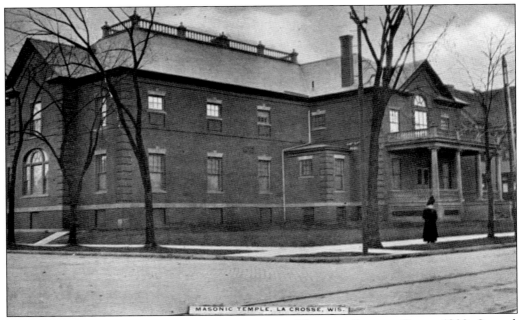

MASONIC LODGE, BUILT 1902. Several Masonic orders have existed in La Crosse, the earliest dating back to 1851. In 1977, the Masons built a new lodge, adding it behind the pictured 1902 building. In 1995, the Masons no longer required the space provided by the older building, so they donated it to the Ho-Chunk Nation.

KNIGHTS OF PYTHIAS, DOKEY, C. 1920. Many may mistakenly think that the fez pictured here indicates that this man is a Mason Shriner, but he is actually a member of a special fez-wearing division of the Knights of Pythias. The La Crosse branch, known as the Kanana Temple, was founded in 1880. The special fez division was called the Dramatic Order of Knights of Khorassan and is represented on the hat by the initials "D.O.K.K."

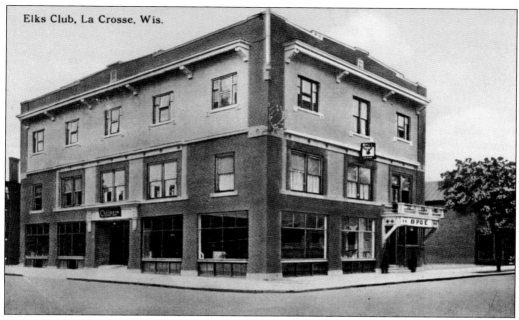

Elks Club, La Crosse, Wis.

**ELKS CLUB.** The local chapter of the Benevolent and Protective Order of the Elks, better known as the Elks Club, was founded in La Crosse in July 1895 with 45 charter members. The national organization was formed much earlier in 1868 in New York. The declared purpose of the group was the welfare and happiness of its members, patriotism, and overall good fellowship among people. In 1912, the La Crosse group obtained its own building at 130 Fifth Avenue North. Both the exterior and interior of that building are seen here. This decked-out clubhouse even had a roof garden! Prominent members of the Elks included Frank Hixon, W.W. Cargill, Odin Oyen, and Henry Gund.

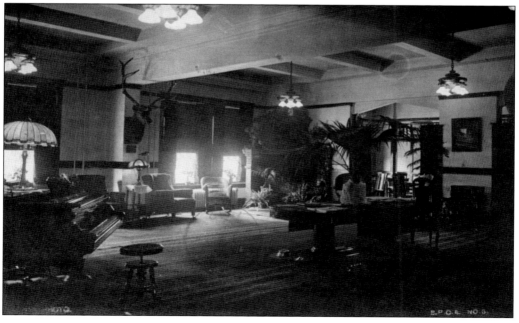

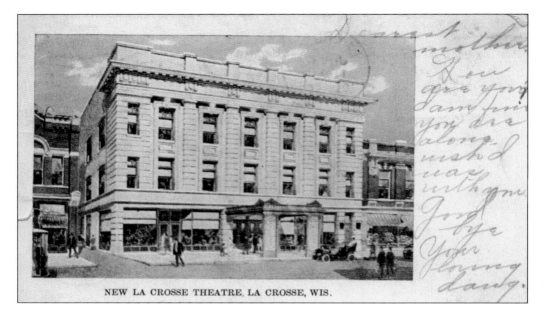

NEW LA CROSSE THEATRE, LA CROSSE, WIS.

**EAGLES AND THE LA CROSSE THEATRE.** The Fraternal Order of Eagles is a nonprofit group founded nationally in 1898. It organizes in the spirit of liberty, truth, justice, and equality in an attempt to improve life. Herman Noll and Emil Hartman founded the local La Crosse aerie, No. 1254, in 1905 with 88 charter members. The organization moved into the pictured La Crosse Theatre building at 119 Fifth Avenue South in 1914, after the Elks Club vacated the space. The Eagles relocated in 1936, constructing their own building just one block south. The La Crosse Theatre building still stands today but is not readily recognizable from this image because its appearance was completely altered in the 1930s.

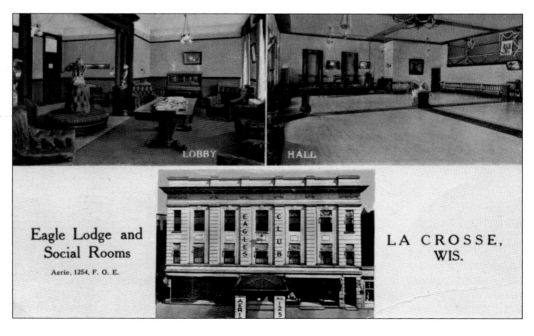

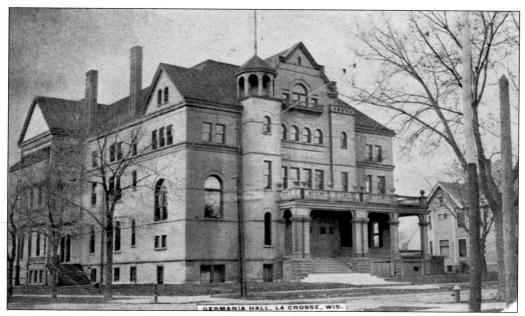

**GERMANIA HALL.** Pictured above is the second building constructed for the German social organization Deutscher Verein. The first structure was destroyed by fire in 1891. Dwarfing its predecessor, this replacement measured 32,000 square feet and took five furnaces to heat. Located at Fifth Avenue and Market Street, this building housed a kindergarten, singing hall, gymnasium, kitchen, bowling alley, and theater. The Deutscher Verein promoted physical, intellectual, and social culture, which included preserving the German language. Anti-German fever during World War I prompted a name change to Pioneer Hall. The Deutscher Verein dissolved in 1937. The building then served as a union headquarters before being torn down in 1966. Now, a fire station stands on the site. The 1894 invitation postcard below is for one of many dances held at Germania Hall.

## DEUTSCHER VEREIN.

Sie sind freundlichst eingeladen mit Ihren Damen, an einem nur für Vereins-Mitglieder am Dienstag Abend, den 23. October in der Germania Halle veranstalteten Saison-Eröffnungsballe Theil zu nehmen. Polanaise 8½ Uhr. Eine Tanzpause findet um 11½ Uhr statt.

Das Vergnügungs-Comite.

Yourself and ladies are cordially invited to attend the first ball of the season, arranged by the Verein for members only, at Germania Hall, Tuesday evening, October 23rd 1894. Polonaise will begin at 8.30. Respectfully

**THE COMMITTE ON ENTERTAINMENTS.**

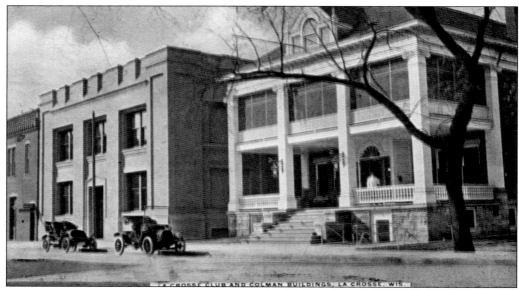

**LA CROSSE CLUB.** This club celebrated the opening of the pictured 115 Fifth Avenue North clubhouse in February 1901. Founded in 1881 as an exclusive group of the city's leading and most wealthy men, the club included A.W. Pettibone, Gideon Hixon, C.L. Colman, John Paul, and Henry Gund, among others. The club's mission was not to change the world but "to provide a comfortable locale for intelligent conversation and relaxing pleasure." The club's prestige came to the forefront in 1886 when it placed the city's first long-distance telephone call. The club started admitting women in 1985 and is still in existence. The clubhouse pictured was demolished in 1964.

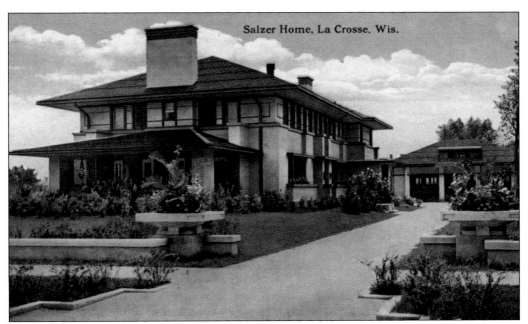

**SALZER HOUSE, BUILT 1912.** Built on a sprawling lot at Seventeenth and King Streets, this Prairie-style home belonged to Henry Salzer. From 1892 to 1916, he was president of the Salzer Seed Company, which was founded by his German American father. A recent Wisconsin Historical Society Press–published book names this residence as one of the 20 most remarkable homes in Wisconsin.

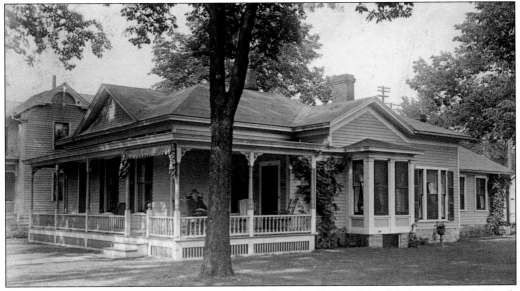

**NELSON AND MARTHA ALLEN, 1911.** The Allen family lived in this house at 131 Tenth Street South probably since its construction sometime in the 1880s. Nelson Allen worked for the C.L. Colman Lumber Company for many years. By the time Martha sent this postcard through the mail in 1911, Nelson, presumably the gentleman in the rocking chair on the porch, had retired.

**STATE STREET, C. 1910.** The postcard image above shows the 1502 State Street home of Ori Sorensen. Mayor of La Crosse from 1909 to 1911 and again from 1913 to 1915, Sorenson lived here from around 1893 to 1905. The postcard below shows the 1425 State Street home of O.A. Hansen, kitty-corner from Sorensen's residence. These once striking upper-middle-class homes, built around the year 1893, have since fallen victim to being duplexed into university student housing. As such, they have been altered with mongrelized porches, additions, siding, and windows. Returning these homes to their former grandeur, however, is still entirely feasible.

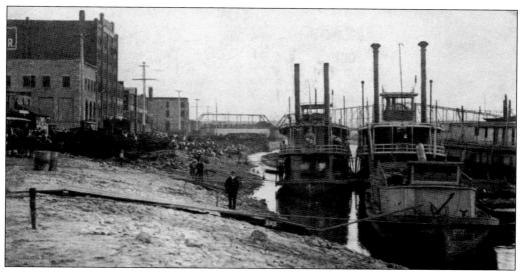

**LA CROSSE HARBOR, C. 1908.** During the steamboat heyday, La Crosse was a major port on the Mississippi River. In this view, there are four steamboats and several barges pulled up to the levee. The small harbor boat *Gypsy* is in the foreground. The water level on the Mississippi River is at a low stage, requiring extra-long gangplanks to be run out from shore to facilitate access.

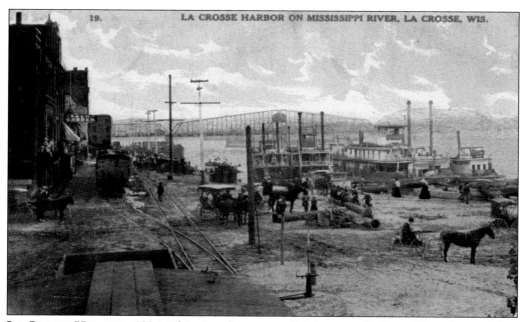

**LA CROSSE HARBOR, 1895.** This view from atop a freight car at the foot of State Street (when railroad tracks used to run through downtown) shows the levee crowded with piled cargo, horses and buggies, and steamboats, including the *Kit Carson* and *Mary B.* The sign for the popular Palm Garden restaurant is visible, and the wagon bridge is in the background.

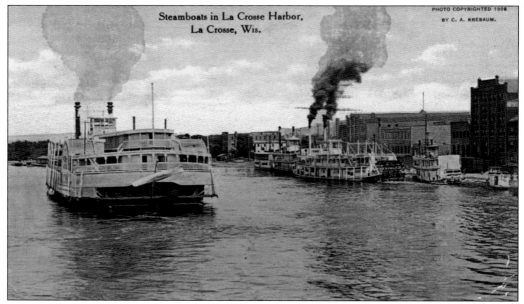

Steamboats in La Crosse Harbor,
La Crosse, Wis.

**LA CROSSE HARBOR, C. 1905.** Pictured here is a bustling day on the Mississippi River. At the levee, the stern-wheeler *Frontenac* is preparing to get underway with smoke pouring from its stacks. In the foreground, the side-wheel excursion steamboat *St. Paul* is making its way upstream. The *St. Paul* enjoyed an exceptionally long career lasting from 1883 until 1940, when it was rebuilt and renamed the *Senator.*

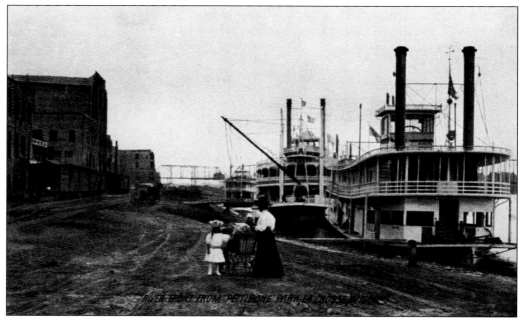

**"RIVER FRONT FROM PETTIBONE PARK."** This c. 1905 postcard is curiously mislabeled as being from Pettibone Park. Pettibone is actually across the Mississippi River from this downtown scene. For a change, the levee is not crowded with people and freight. Only a woman with children and a baby carriage is visible.

# Four

# BUILDING A CITY

Even though much architectural heritage has been lost, La Crosse still has an impressive core of historic buildings, many of which were constructed for governance, educational, medical, and religious purposes. Thanks to the efforts of many individuals and groups like the Preservation Alliance of La Crosse, founded in part as a reaction to the 1977 demolition of the La Crosse Federal Building (the old post office), the pendulum has swung away from razing buildings and in favor of restoration.

A concerted movement of historic revitalization in La Crosse started in 1990. Public and private cooperation, the nonprofit organization Downtown Mainstreet, Inc., and the comprehensive City Vision 2000 Master Plan all played a major role in the restoration of over 100 building exteriors and the historic streetscaping of 65 of the city's downtown blocks from 1990 to 2000. The spirit of historic revitalization then spread from downtown to the rest of the city, inspiring many a home and business owner to return buildings to their former historic glory.

After over 10 years of historical restoration, La Crosse has seen an increase in tourism and received the prestigious Great American Main Street Award from the National Trust for Historic Preservation. Some of the buildings featured in this chapter still remain and have been masterly restored, while others are almost unrecognizable, desperately needing repair. Some buildings have been completely lost and exist only in photographs and memories.

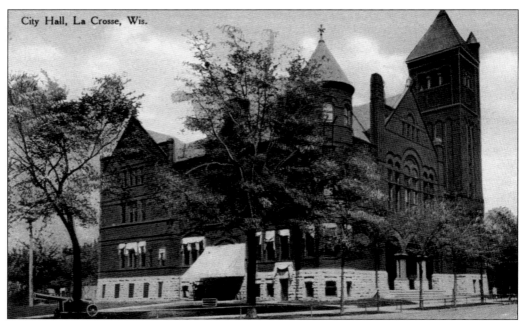

City Hall, La Crosse, Wis.

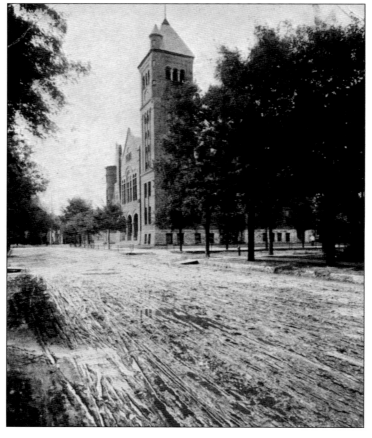

CITY HALL. Dedicated in 1892, La Crosse's second city hall was an imposing example of Romanesque Revival architecture, featuring white cut limestone for the basement, red brick for the walls, and terra-cotta for decoration. Local architects Stoltze and Shick designed the building, which cost just over $54,000 to erect. Located on State Street, between Fifth and Sixth Streets, the south-facing entrance featured three arches at ground level, which were flanked by a four-story round tower to the west and a square clock tower to the east. The clock tower rose up 128 feet until the upper portion was removed in the 1930s. The building was razed in 1969.

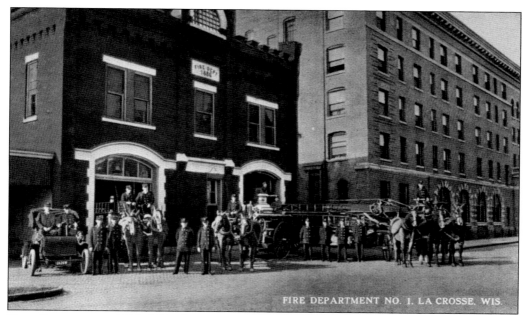

**FIRE STATION, C. 1910.** This fire station was built in 1886 at 414 State Street and served the city until its demolition in 1967. Pictured are the chief's automobile, hose and equipment cart, Nott steam pumper, and hook and ladder wagon. The Stoddard Hotel is in the background. The building was altered over the years, including the addition of a bell tower in 1889.

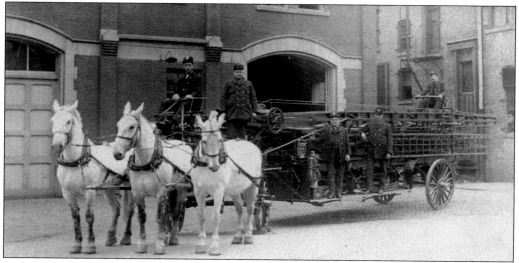

**FIRE WAGON, C. 1905.** Three horses pulled this hook and ladder belonging to Station No. 1. It had 70-foot and 45-foot extension ladders and weighed 7,400 pounds. Horses started pulling La Crosse's fire wagons in 1874. With the advent of automobiles and fire engines, the process of phasing out horses began in 1916, with the last horses retiring in 1926.

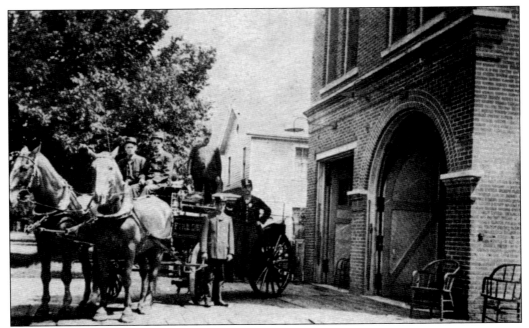

**FIRE STATION, 1896.** Station No. 3 was located at the corner of Sixth and Mississippi Streets. The company wagon carried 1,300 feet of hose and weighed 4,000 pounds. A foot-operated gong under the driver's footrest was used to clear traffic on the way to fires. The firemen pictured here are Christe Hansen, Nathan Bradfield, J. Sauer, H. Olsen, and C. Schlong.

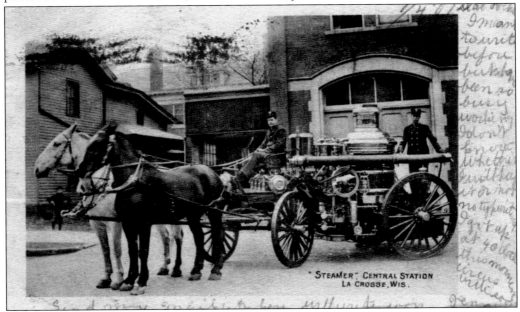

**STEAMER.** Here, firefighters pose with the Nott steam pumper, purchased for $5,000 in 1905. It weighed 8,000 pounds and was in service until 1925. During the big 1912 fire in West Salem, Wisconsin, the pumper was transferred via rail to help extinguish the blaze. It is now part of the collection of the La Crosse County Historical Society.

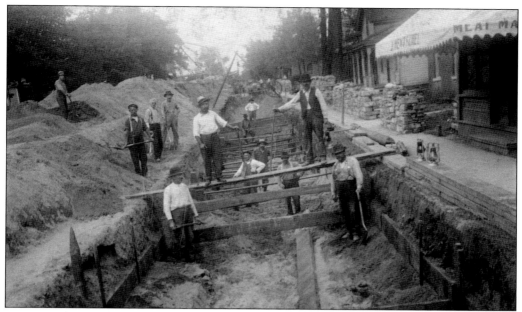

**VIADUCT, C. 1915.** Above, a construction crew completes work in front of the Joseph Hentschel Meat Market on the 400 block of Rose Street. In 1912, the Railroad Commission of Wisconsin condemned and then ordered the replacement of the nearby 1883 timber viaduct, constructed because of the dangerous multitrack crossing. The replacement viaduct, pictured below, opened to traffic in 1915 and fixed the abrupt approaches of the old viaduct. This improvement provided travelers with safer, longer, and more gradual inclines over the tracks. However, the expanded approach overshadowed the nearby homes and businesses. In 1979, railroad engineers discovered that the 1915 viaduct was weak, so it was torn down and replaced with the plain concrete bridges in place today.

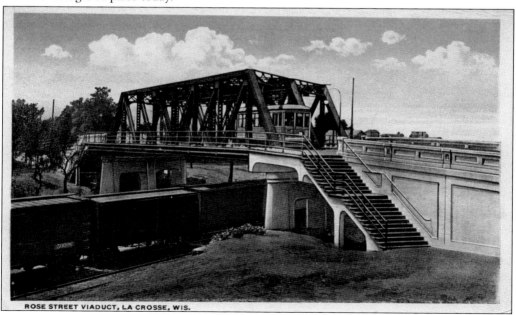

ROSE STREET VIADUCT, LA CROSSE, WIS.

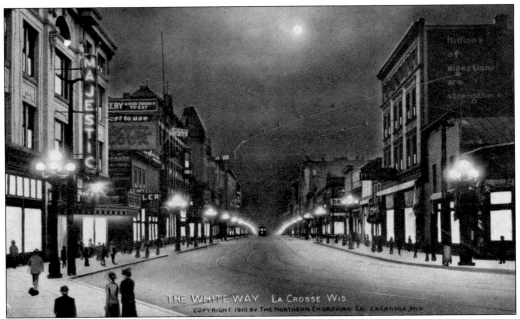

**STREET LIGHTING.** Both of these postcards show a westward view of the 500 block of Main Street. The postcard above commemorates the arrival of new high-quality streetlights. Citizens pledged $10,000 to fund the new lights, and a parade celebrating their installation was held on October 31, 1910. The Minneapolis-based Flour City Ornamental Iron Works Company produced the decorative lights. The 1912 postcard below provides a clear view of the design. From 1910 to 1928, these lamps were installed to replace the 150-foot-high arc streetlights. Installed in 1882, those fixtures had become ineffective due to the growth of tree cover. During the downtown revitalization project, the city in partnership with Downtown Mainstreet, Inc., purchased replicas of these historic cast-iron streetlamps. The first replica lampposts were installed on Pearl Street in 1996.

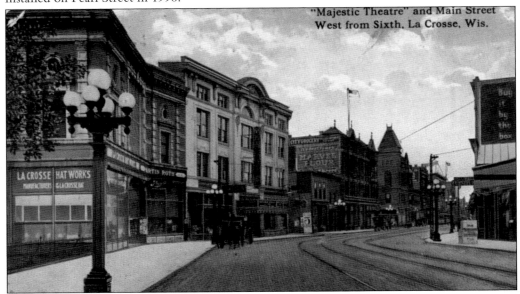

**PUBLIC LIBRARY, 1888.** The La Crosse Public Library was built in 1888. It was funded by a bequest from Cadwallader Washburn, who was a prominent businessman, Civil War general, US congressman, and governor of Wisconsin. It was located on the site of the current library at Eighth and Main Streets. The children's room, located on the second floor of the round tower and accessed via a spiral staircase, was especially popular.

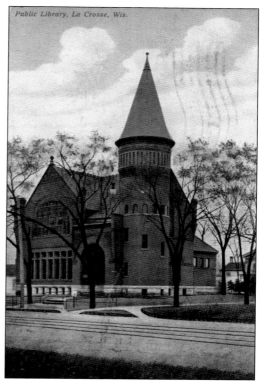

Public Library, La Crosse, Wis.

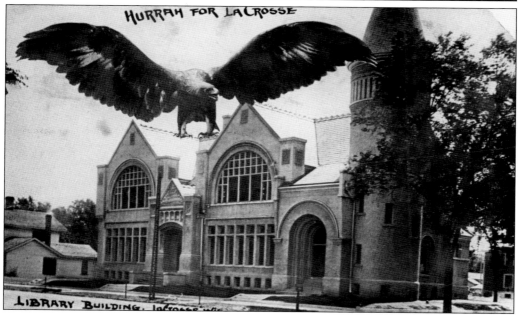

**PUBLIC LIBRARY ADDITION, 1908.** Research found no specific reason why a giant bird of prey is depicted perching on the addition to the library on this postcard. What is known is that the 1908 addition doubled the size of the building, which was the oldest public library building in Wisconsin before it was razed in 1966.

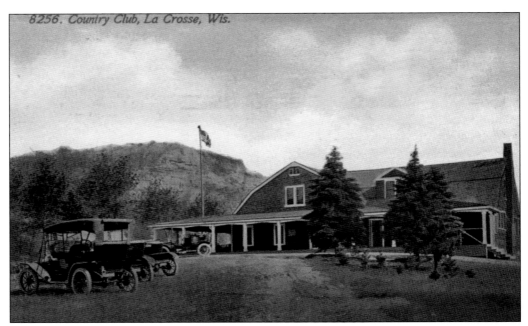

8256. Country Club, La Crosse, Wis.

**COUNTRY CLUB.** The La Crosse Country Club opened in 1900 as the privately owned Schaghticoke Country Club. In 1912, the membership donated the land, located just to the north of Grandad Bluff, to the La Crosse Park Board. The members continued to operate the golf course through a series of leases with the city until a public referendum in 1990 converted it to a municipal course, effective January 1995. Currently, it operates as Forest Hills Public Golf Course. The original clubhouse, which opened in 1901, was torn down in 2013. The La Crosse Country Club remains in operation as a private club in a new location. It built a new course and clubhouse in Onalaska in 1994.

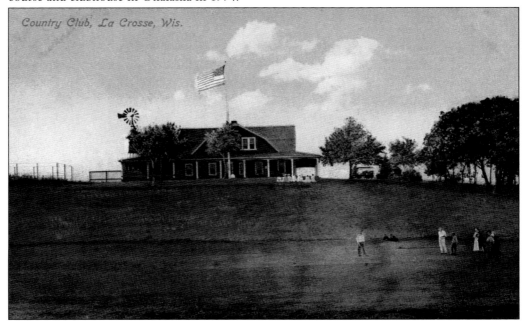

Country Club, La Crosse, Wis.

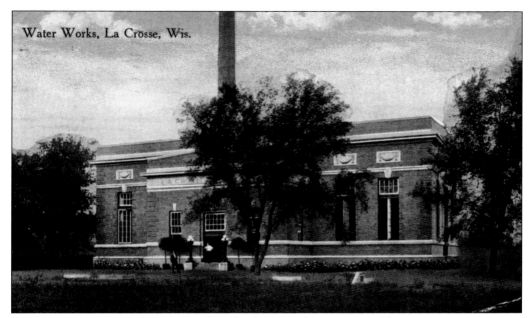

Water Works, La Crosse, Wis.

**WATERWORKS.** Located near Myrick Park, the pump house pictured here went into operation in 1914. It replaced the 1880 pump house located downtown on King Street, which despite being enlarged in 1895, could no longer meet the demands of the growing city. The 1914 pump house is still used for municipal purposes, while the original has been converted into a regional art center.

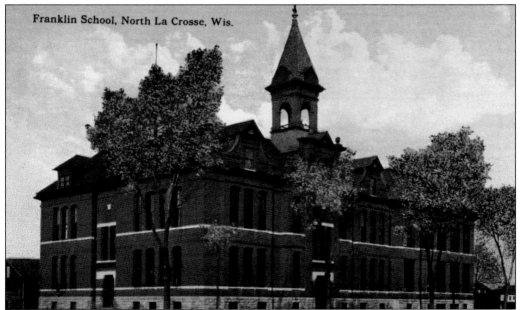

Franklin School, North La Crosse, Wis.

**FRANKLIN SCHOOL.** Franklin, located on Kane and Gillette Streets, was known as the Seventh District School from 1887 to 1907. The belfry tower, seen here, summoned students to classes. This building was torn down and replaced in 1955. Franklin and Roosevelt Schools are now combined at the new Northside Elementary School building.

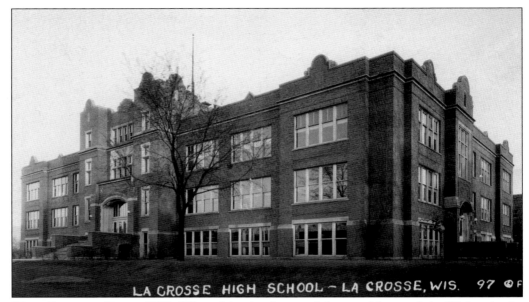

LA CROSSE HIGH SCHOOL - LA CROSSE, WIS. 97 © F

**HIGH SCHOOL, BUILT 1907.** When this school opened, it was nicknamed the "Palace in the Prairie." It was located on Cass Street between Fifteenth and Sixteenth Streets. In 1927, after Logan High School opened on the city's North Side, it was renamed Central High School. A new Central High School opened in 1967 on Losey Boulevard. Old Central was demolished in 1972. The site is now Weigent Park, named after coach and teacher Walter "Babe" Weigent.

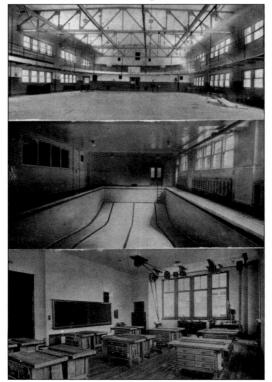

**HIGH SCHOOL, HIXON ANNEX.** In 1912, local businessman and philanthropist Frank Hixon offered to fund an annex to the high school for a manual training department. Completed a year later, the annex included a machine shop, mill and lathe room, forge, foundry, swimming pool, and gymnasium, providing students with some of the best facilities in the state.

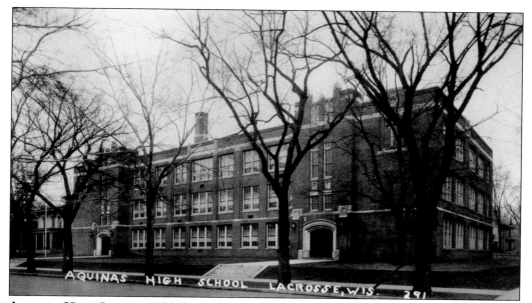

**AQUINAS HIGH SCHOOL.** This Roman Catholic high school opened in 1928 with 157 students. Seen in this view are the main entrances located on Eleventh Street between Cameron and Cass Streets. The building was wisely designed to allow for expansion. Increases in enrollment have led to multiple additions and renovations over the years.

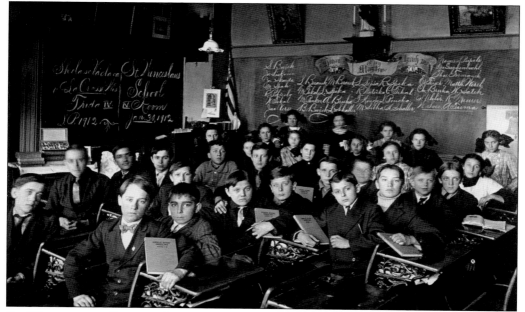

**ST. WENCESLAUS SCHOOL, JANUARY 1912.** This Catholic grade school was located at Tenth and Winnebago Streets until 1969, when it merged with St. Joseph's Cathedral Catholic School. St. Wenceslaus primarily served the Bohemian community. In this classroom view, there are Czech words on the blackboard along with student surnames like Tikal, Spika, and Prucha.

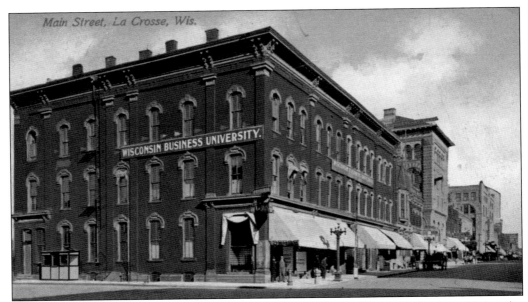

**WISCONSIN BUSINESS UNIVERSITY.** Incorporated in 1892, the Wisconsin Business University was a private school located on the northeast corner of Third and Main Streets. The founding president was Frank Toland. Over the next 48 years, eight other members of the Toland family were affiliated with it, either as students or officials. The Wisconsin Business University graduated more than 10,000 students before closing in 1941.

**GEORGE STREET, C. 1910.** Visible in this street view is the Bethel Lutheran Church. In 1889, North Side Norwegian immigrants built it because they wanted a church closer to their homes. In 1899, it broke with the United Norwegian synod and joined the Lutheran Free Church affiliation due to ethnic diversification in the congregation. The organization left this building in 1958, moving to its current location on Loomis Street.

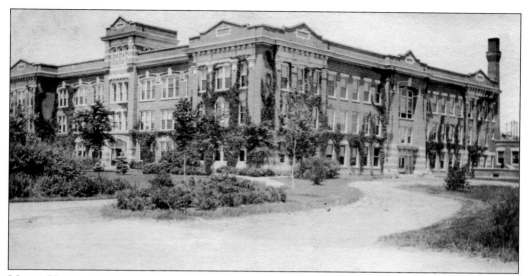

**MAIN HALL, JUNE 1918.** This was the only building on campus when the University of Wisconsin–La Crosse opened as the La Crosse Normal School in 1909. In addition to an auditorium and classrooms, Main Hall originally housed science laboratories, two gymnasiums, the library, and a teacher training school with elementary students. Students used to plant ivy along the exterior walls of Main Hall.

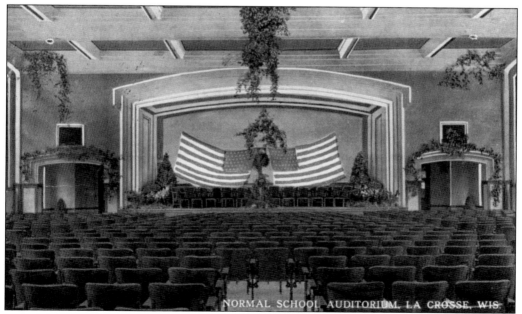

**MAIN HALL AUDITORIUM, C. 1910.** When it opened, this was one of the largest public-gathering spaces in La Crosse. One notable feature, barely visible here and no longer in place, is the auditorium's light wells located along the sidewalls. They were in place to provide sunlight because early electricity was sometimes unreliable. In 2014, the auditorium underwent a major renovation that restored many of the original architectural details, but not the light wells.

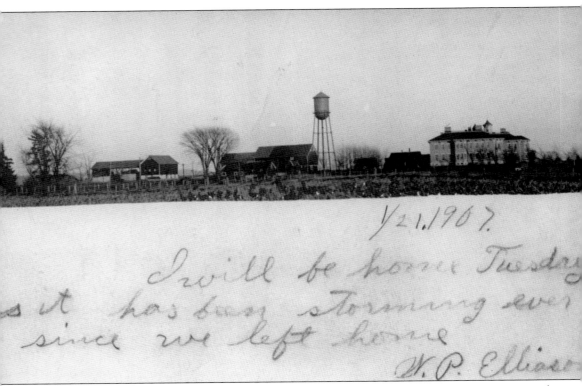

**LA CROSSE COUNTY, INSANE ASYLUM.** Located in West Salem, this 700-acre complex opened in 1888 as part of a statewide movement to house persons with mental illness closer to home. Previously, such patients were sent to the state hospital in Mendota, or worse yet, they were placed in prisons or jails. Ailments that led to institutionalization included schizophrenia, bipolar disorder, cognitive difficulties, dementia, and even epilepsy. A superintendent and his wife, plus a three-member board of trustees, ran the asylum. No medical training was required for these positions. Upon its opening, the *La Crosse Chronicle* reported that the asylum received "the first installment of chronic insane . . . in charge of Superintendent McKown and five assistants. They numbered 24 and came from Mendota . . . As these unfortunates were from this county, some were pleased at the idea of coming back to La Crosse where they would be at home with friends." This image from 1907 shows the asylum and farm, which could house up to 100 patients.

La Crosse County, Asylum
West Salem Wis

**LA CROSSE COUNTY, INSANE ASYLUM ADDITION.** This image shows the asylum after a 1911 addition greatly expanded the size of the institution. In the foreground is one of the many farm fields. Referred to as inmates, many patients worked on the 496-acre farm as a form of therapy and to offset costs. The farm produced vegetables, meat, dairy, and fruit for use at the asylum. Any extra produce was sold. Eventually, the name of the institution changed to La Crosse County Hospital, and in 1968, its name changed to Lakeview. The pictured building was torn down in 1976 and replaced by a new 260-bed facility that is still in use. Currently, Lakeview is better known as a nursing home, but it still serves people with developmental disabilities and mental illness. Its mission is to supplement existing private health care, especially for those with limited means. The philosophy of the institution has changed over the years. It now strives to help patients maintain their roles in the community rather than remove them from it.

COURT HOUSE AND POST·OFFICE- LA CROSSE, WIS. 38 © Frey

**LA CROSSE COUNTY, COURTHOUSE.** The third courthouse built for the county encompassed a full city block, bounded by Third, Fourth, State, and Vine Streets. The exterior featured red sandstone surfacing, a slate roof, and a central clock tower. The clock was powered by water, but silt clogged the mechanism shortly after the building's dedication in 1905. The clock did not become operational again until 1920, when it was converted to run on electricity. Following the courthouse's demolition in 1965, a Montgomery Ward department store was built on the site. A decrease in sales led that store to close in 1986, and in 1990, the vacant building was torn down. The block is now a parking lot, but there are new development plans under consideration for the site.

COURT HOUSE, LA CROSSE, WIS.

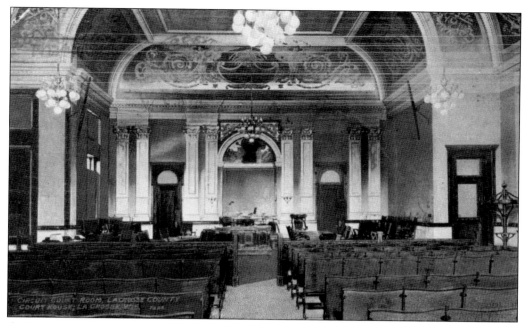

**COURTHOUSE INTERIOR, C. 1910.** The interior of the courthouse featured marble floors, brass railings, and classically inspired murals painted by the Odin Oyen interior-decorating firm. The circuit courtroom featured a mural of the figure Equity balancing a sphere in each hand. Michael Hackner added eight more murals representing industry, art, science, and education in 1925 when the C.E. Hammes Company repainted the courthouse.

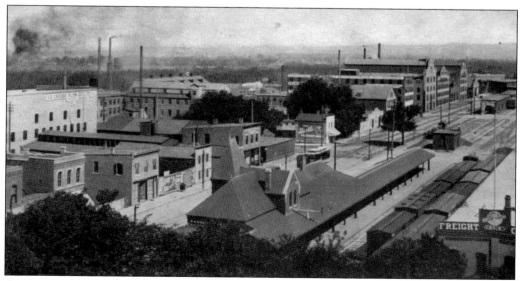

**COURTHOUSE VIEW, C. 1912.** The view in this postcard looks northwest from the top of the courthouse. In the foreground are the Chicago & North Western Railway Depot and Freight House. To the left, note the building labeled La Crosse Plow Company, a business that later became part of Allis Chalmers.

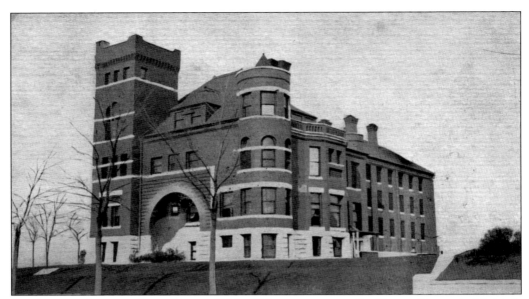

**LA CROSSE COUNTY JAIL, BUILT 1890.** This structure was La Crosse County's third jail. Situated at Tenth and Zeisler Streets near the edge of the marsh, it was solidly built of brick and stone in a style befitting a jail. It was demolished in July 1965 when new facilities were constructed downtown.

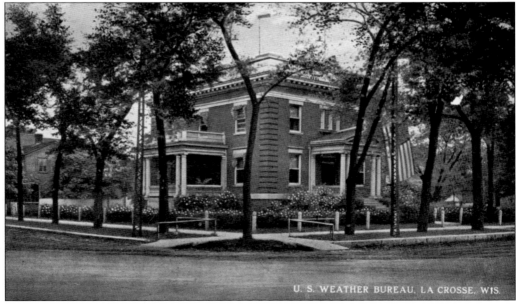

**US WEATHER BUREAU, C. 1907.** Located at Fifth and Cass Streets, the always on-call weather observer conveniently lived in the upstairs of this building. The offices and instruments were located on the ground floor. The weather service later moved to space in the post office building and relocated to its current location atop the bluff on County Highway FA in 1995.

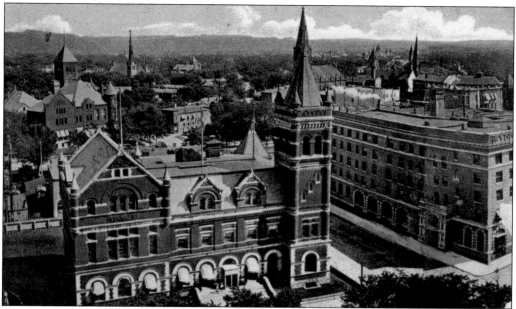

**US FEDERAL BUILDING.** Located at the northwest corner of Fourth and State Streets, construction on this building finished in 1890. It was commonly called the post office building, even though it contained other federal offices as well. The image above provides a spectacular view of the 112-foot tower. The c. 1910 image below is of the north side of the building, where in 1933, a 76-foot-long addition was built. Plans for a new post office building in the 1970s included the demolition of the old structure. A movement of local residents tried unsuccessfully to save the historic post office from the wrecking ball in 1977. However, the preservation efforts did result in the careful removal of the old building's decorative terra-cotta relief panels, which were then installed on a commemorative memorial at the new post office.

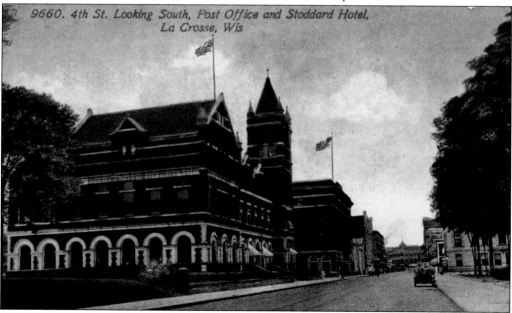

9660. 4th St. Looking South, Post Office and Stoddard Hotel, La Crosse, Wis

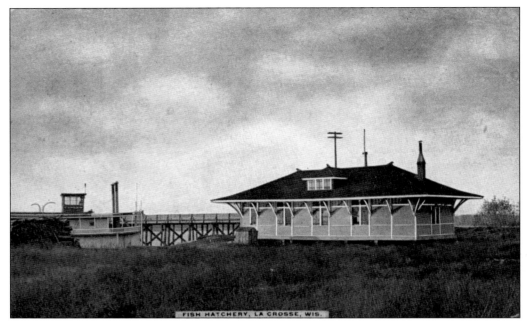

FISH HATCHERY, LA CROSSE, WIS.

**US Fish Hatchery, c. 1905.** This fish hatchery operated in Copeland Park in the early 20th century. In the background is the Clinton Street Bridge. To the left is the stern-wheel steamboat *Curlew*, which the US Bureau of Fisheries owned from 1902 (when it was built) until 1917. The bureau moved to a newly constructed building in Riverside Park in 1924.

MISSISSIPPI RIVER
DAM NO. 7 — LA CROSSE, WIS.

**Lock and Dam No. 7.** One of 29 dams on the upper Mississippi, Lock and Dam No. 7 was built under the direction of the Army Corps of Engineers between 1934 and 1937. The original control building is now a popular visitor center. The lock-and-dam system helps control floodwaters, allows recreational boaters to lock through, and provides a stable nine-foot-deep channel for commercial shipping.

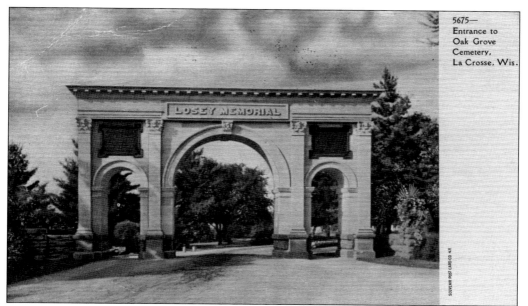

**LOSEY MEMORIAL ARCH.** This arch is the grand entrance to Oak Grove Cemetery. It was dedicated in 1902 in honor of Joseph Losey. The plaques on the arch state, "Joseph W. Losey, he found this cemetery neglected and desolate. He transformed it into a place of charm and beauty." On its centennial in 2002, the arch was rededicated and added to the National Register of Historic Places.

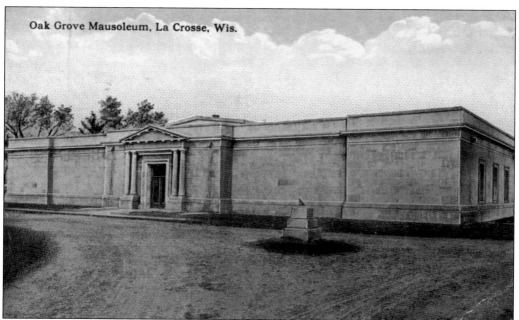

Oak Grove Mausoleum, La Crosse, Wis.

**OAK GROVE CEMETERY, MAUSOLEUM.** Constructed in 1912, this stately structure has a simplified classical style. The marble interior contains 590 burial crypts and a chapel. To the right of the entrance, note the small pedestal that was topped by a sundial calibrated to the exact latitude of La Crosse until it was stolen.

99

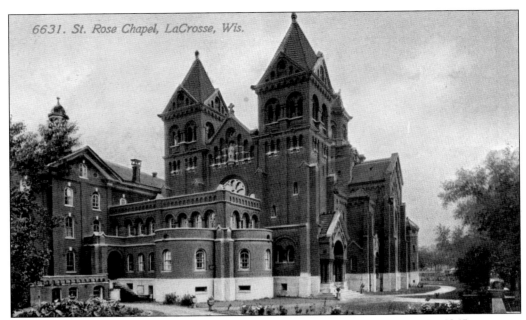

6631. St. Rose Chapel, LaCrosse, Wis.

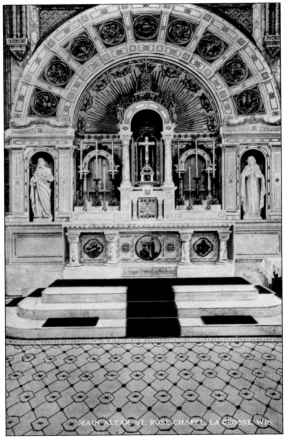

MAIN ALTAR ST. ROSE CHAPEL, LA CROSSE WIS.

**ST. ROSE CONVENT.** In 1865, the Franciscan Sisters of Perpetual Adoration pledged to God to pray constantly and to build "as beautiful a chapel as our means will allow." Construction on the Mary of the Angels Chapel began in 1901, under Milwaukee architect Eugene Liebert, and finished in 1906.

**ST. ROSE CONVENT, MAIN ALTAR.** Eugene Liebert used white and colored marble along with Mexican onyx and inlaid-glass mosaics in his designs for the altars in the Mary of the Angels Chapel. On the other side of the main altar wall is the Chapel of Perpetual Adoration, which is still used by the Franciscan Sisters to maintain their 149-year-old vow of constant prayer.

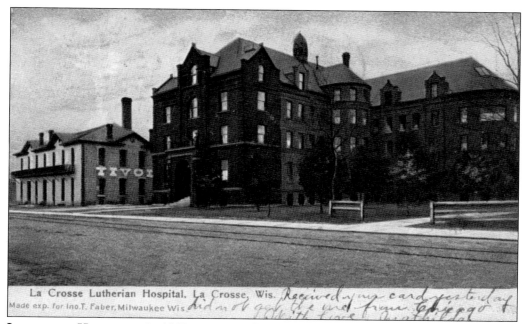

La Crosse Lutherian Hospital. La Crosse, Wis.
Made exp. for Ino.T. Faber, Milwaukee Wis.

**LUTHERAN HOSPITAL.** In 1899, a group of Lutheran pastors incorporated this hospital. In 1902, it opened this South Avenue building, which was next to the Tivoli, a beer garden and dance hall (seen to the left). The fourth floor of this hospital building caught fire in February 1961, and all of the patients (over 120) were safely evacuated in freezing temperatures.

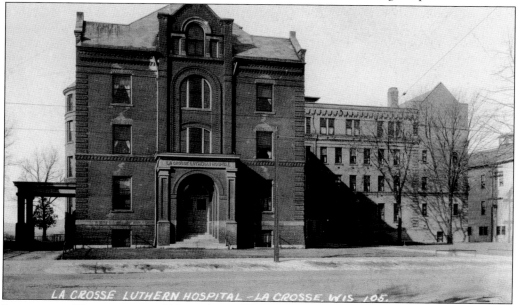

**LUTHERAN HOSPITAL, C. 1927.** This postcard shows additions added in 1917 and 1927. Significant additions were also made to the hospital in 1954, 1965, 1973, and 1977. A separate nurses home was built in 1923. Today, this medical complex is a modern and award-winning health care facility made up of a mix of buildings, including a brand-new wing completed in 2014.

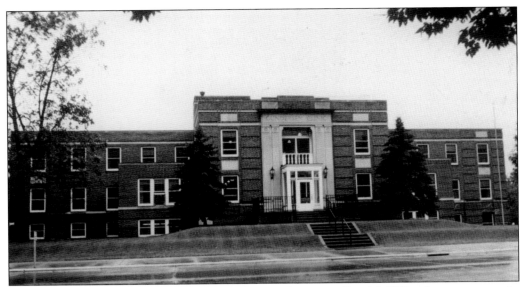

**GUNDERSEN CLINIC.** A Norwegian immigrant and surgeon, Dr. Adolf Gundersen came to La Crosse in 1891 and founded the Gundersen Clinic. Three of his sons also became physicians. Thus far, there have been four generations of Gundersens practicing medicine in La Crosse. Originally downtown at Fourth and Pearl Streets, the clinic moved to the pictured South Avenue building in 1930.

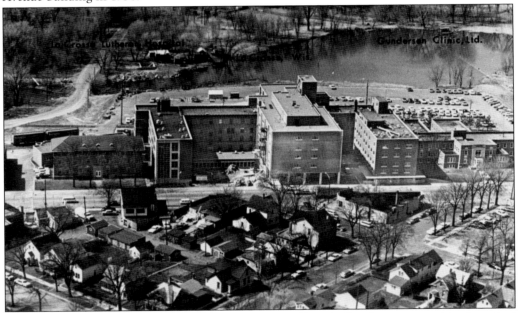

**GUNDERSEN CLINIC AND LUTHERAN HOSPITAL.** Historically, these two entities have had a very close working relationship. Dr. Adolf Gundersen was Lutheran Hospital's first medical director. Gundersen Clinic's 1930 location on South Avenue was just to the left of Lutheran Hospital, as seen in this overhead view. In 1996, Lutheran Hospital merged with Gundersen Clinic, becoming Gundersen Lutheran. Currently, this system of medical providers operates under the name Gundersen Health System.

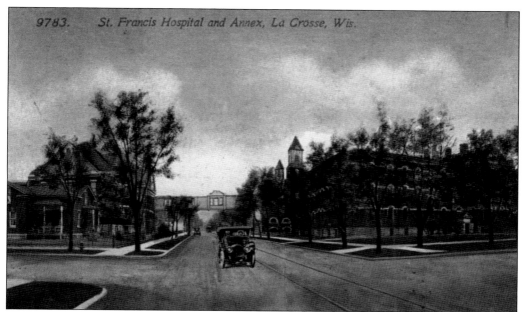

9783. *St. Francis Hospital and Annex, La Crosse, Wis.*

## ST. FRANCIS HOSPITAL.

This hospital, La Crosse's first, was founded by the Sisters of Perpetual Adoration in 1883 as a 35-bed facility at Tenth and Market Streets. The St. Francis School of Nursing was established there in 1902, and St. Ann's Maternity Hospital was added in 1912. Seen here, a skywalk across Market Street provides a link to an annex, St. Ann's, and the School of Nursing.

## ST. FRANCIS ADDITIONS.

St. Francis Hospital was immediately successful and began to expand, adding east and west wings in 1886, a chapel in 1891, and another wing to the west in 1896. The original hospital building was razed in 1931 to make way for an eight-story addition, seen here, called the Market Street Wing, designed by local architects Parkinson and Dockendorff.

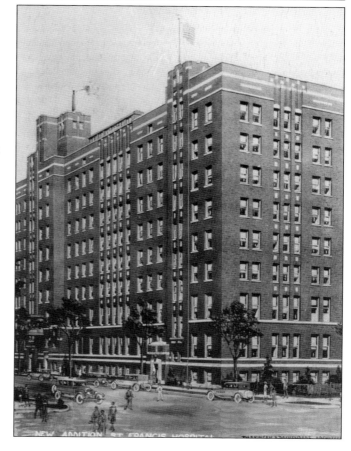

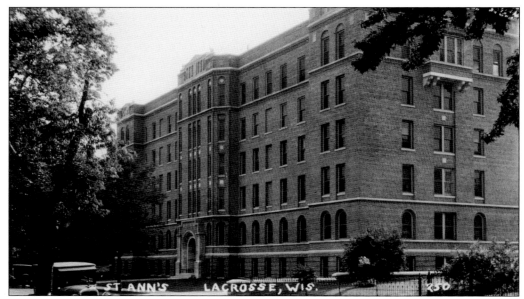

**ST. ANN'S MATERNITY HOSPITAL.** In addition to St. Francis Hospital, the Sisters of Perpetual Adoration also established the first maternity hospital in the area in 1912. Originally named St. Ann's Obstetrical Hospital, this Parkinson and Dockendorff–designed building opened in 1927. Although its building is still in use, St. Ann's closed in 1963 when a new maternity department was built within St. Francis Hospital.

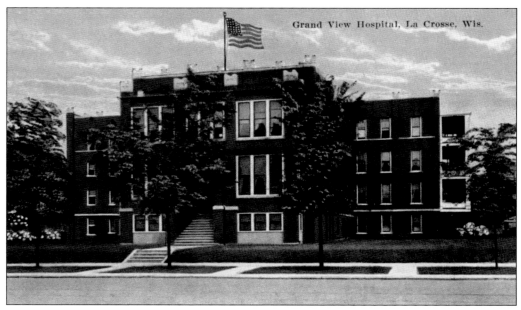

**GRANDVIEW HOSPITAL.** Dr. William Henke founded this medical institution in 1914 on the 1700 block of Main Street. Substantial additions were made to the building in the 1920s. In 1940, a merger between Grandview and St. Francis was negotiated, and on the day the papers were to be signed, Henke died of a heart attack. Grandview Hospital continued to operate until 1969.

# Five

# A CITY ALIVE

La Crosse is a great place to live and a popular tourist destination. The La Crosse Visitors and Convention Bureau reports that the city currently hosts over one million visitors per year from all over the world. Many visit the area to partake in the city's unique shopping, art, dining, history, entertainment, and festivals. Also, the region's scenic beauty and year-round outdoor activities attract nature and sports enthusiasts.

La Crosse's citizens know how to enjoy themselves, and they readily share that knowledge with visitors, making the city an affable host. The people of La Crosse live active, healthy, and involved lives. They take full advantage of recreational opportunities and fuel the city's nightlife found at taverns, cafés, theaters, music venues, and art galleries. The area's three major institutions of higher learning add an array of vibrant students to the population every year, thus ensuring a sizable youthful element in the city. La Crosse typically scores nationally as one of the best cities of its size in which to live.

This chapter attempts to document a small sampling of the city's most memorable aspects, which includes special events, leisure activities, nightlife, and even catastrophes. Some of the happenings in this chapter were but one-time affairs, while others continued as regular sights or annual events. Nonetheless, all have contributed to La Crosse's culture and quality of life, thus leaving a permanent mark.

WE KNEAD THE DOUGH
and YOU NEED THE ENJOYMENT
*That is yours if you attend the*

# INTERSTATE FAIR
## LA CROSSE
### WISC.

September
26th, 27th
28th & 29th

COPYRIGHT, 1907, BY KAUFMANN & STRAUSS CO.

INTER-STATE FAIR
LA CROSSE
WIS.

THOROUGHBREDS

Sept. 21-25, 1914

C. S. VAN AUKEN Secy

ANGLO-AMER. P. C. CO., N.Y.

**LA CROSSE COUNTY INTERSTATE FAIR.** In 1890, this fair replaced a smaller county fair held in Myrick Park since the 1870s, moving the fair to larger grounds across the street. In the early years, the fair was often advertised using postcards such as those pictured here. In addition to livestock and agricultural exhibits, a popular attraction at the fair was horse racing, which might explain why the postcard at left features a sophisticated-looking woman and her horse. In 1957, the fair moved to its current home in West Salem. The University of Wisconsin–La Crosse, then known as the Wisconsin State College at La Crosse, absorbed the former fairgrounds, which became the site of the university's stadium.

**HORSES AT THE INTERSTATE FAIR, C. 1910.** The back of this postcard informs the reader that this stoic horse owner, wearing a fancy dress and an impressive bonnet, is prepared to display her ponies Jip and Eve. Note the La Crosse County Interstate Fair poster attached to the barn in the background.

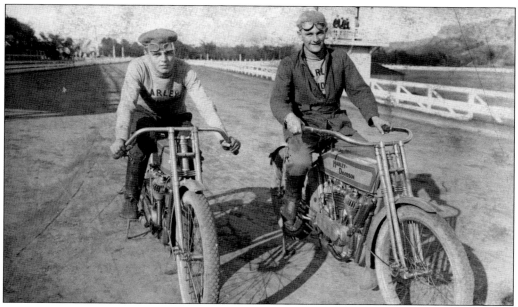

**INTERSTATE FAIRGROUNDS, MOTORCYCLE RACING.** In this c. 1914 image, two young men sport Harley–Davidson shirts and motorcycles as they pose on the track of the La Crosse County Interstate Fairgrounds. Note the tower near the track and, to the far right, Miller's Bluff in the background. The Majestic Studio in La Crosse produced this postcard.

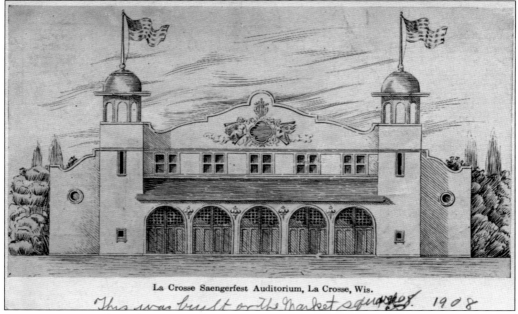

La Crosse Saengerfest Auditorium, La Crosse, Wis.

*This was built on the market square* 1908

**SAENGERFEST.** After a last–minute bid and much to the surprise of citizens, La Crosse was chosen to host the 1908 Saengerfest celebration, a large gathering of German singing societies. The city lacked a proper auditorium to stage the 1,800–to–2,000–person chorus and to house the expected audience, so residents worked quickly to build a slightly rougher version of the hall pictured above. Due to time constraints, the structure was never stuccoed or painted. The building's bare boards were instead decorated with large fabric banners, thus distracting from the unfinished surface. This auditorium, which could seat up to 3,600 people plus an additional 500 in overflow, was located in Market Square on Fourth and Jay Streets. This building was a temporary structure, and the only record of its existence is in 1908.

THE BATHING BEACH LACROSSE, WIS

**PETTIBONE BEACH, SWIMMING.** Pettibone Beach, seen above around 1926, hosted 300 to 500 bathers on a typical day. Manufacturing waste and raw sewage created polluted conditions, closing the beach from 1931 to 1933. The impetus for the 1931 closure was the death of a 16-year-old who contracted a sinus infection that manifested into meningitis. Improved environmental measures did not precede the reopening of the beach in 1933, and people once again became ill with infections, closing the beach from 1933 to 1939. Water health began to improve when communities invested in sewage treatment plants; La Crosse's opened in 1937. The Army Corps of Engineers' Nine-Foot Channel Project, nearing completion in the late 1930s, also helped by speeding-up the river's current, therefore preventing stagnant and festering pollution.

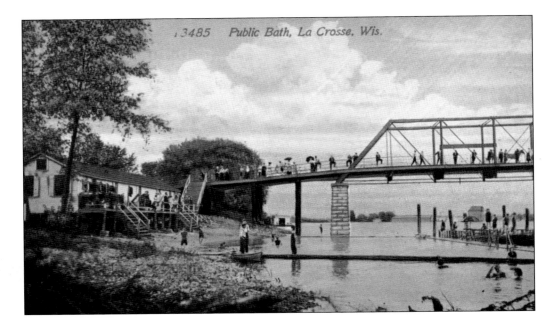

PETTIBONE BEACH, BATHHOUSE, 1904 TO 1925. This bathhouse was constructed as a place for swimmers to don their bathing suits. Painted white in color, its long and narrow frame was originally supported by wooden pile foundations, which were later replaced by concrete ones. It was located at a good swimming location where the riverbed gradually sloped, and even nonswimmers safely ventured out 150 feet from shore. As a safety precaution, a warning boom was laid where the river became too deep for wading. At the 1904 dedication, a swimming instructor was on-site to aid any troubled swimmers. In 1904, it cost 5¢ to rent a bathing suit and another 5¢ to rent a locker.

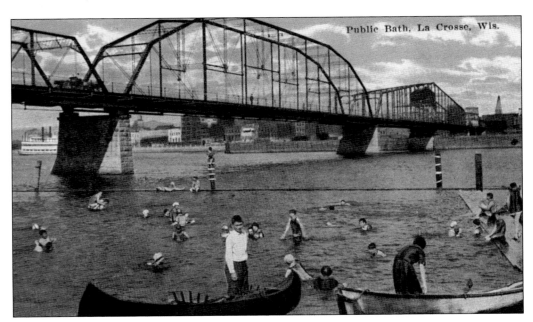

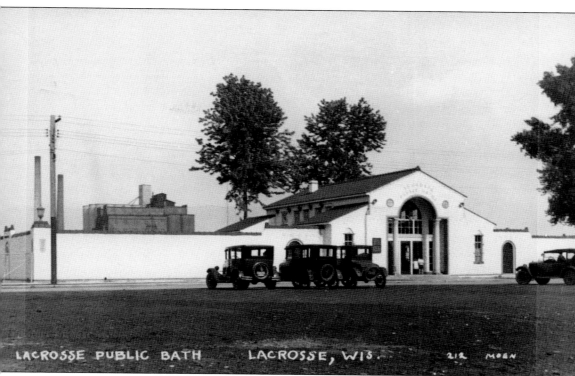

LACROSSE PUBLIC BATH    LACROSSE, WIS.    212    MOEN

**PETTIBONE BEACH, NEW BATHHOUSE.** In the 1920s, the Elks Club advocated for the construction of a new bathhouse at Pettibone Beach. Members held a bazaar, raising $10,000 for the project. The original bathhouse was vulnerable to flooding, the long and steep stairways were unsafe, and the dressing rooms were too small. Local architect Otto Merman designed an eclectically styled bathhouse to replace the modest 1904 predecessor. The stucco building boasted a prominent red Spanish-tile roof, clerestory windows, a spectator balcony, exposed timber trusses, marble toilet facilities, ornamental California tile, and an arched portico with Corinthian columns. A crowd of 5,000 people attended the July 21, 1926, dedication of the new bathhouse. The bathhouse was considered to be extremely modern and sanitary because its open-air locker rooms were purified by the sun and washed by the rain.

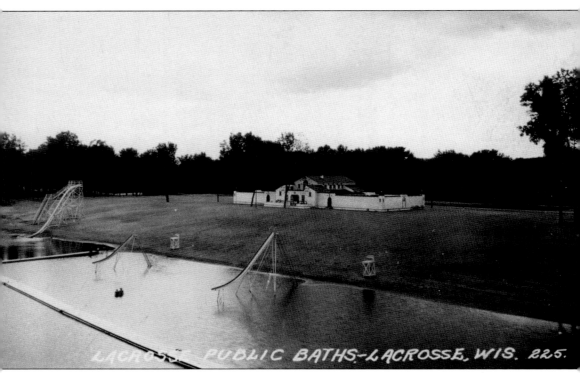

LACROSSE PUBLIC BATHS-LACROSSE, WIS. 225.

**PETTIBONE BEACH, BATHHOUSE RENEWAL.** The new bathhouse was designed to accommodate up to 700 bathers, but for several years, it went unused as a result of polluted river conditions. The unclean water left swimmers vulnerable to ear, nose, throat, and skin infections. During the closing of the beach in 1933, the bathhouse fell into a state of disrepair due to rampant vandalism. Much of the damage was fixed when the bathhouse reopened in 1939. In the years following, swimmers increasingly came to the beach already dressed for water activity. The facility's decreased use fostered in a new period of neglect. Entrances and windows were boarded shut, weeds grew through the floors, and the distinctive red Spanish–tile roof was removed. Moreover, a lack of routine maintenance resulted in cracked walls and tiles, broken windows, and peeling paint, and vandals gutted the building's plumbing and stole its light fixtures. The building remained in this sorry condition for many years until 2001, when the city provided funds for renovation. In 2002, a rededication ceremony marked the completion of the restoration.

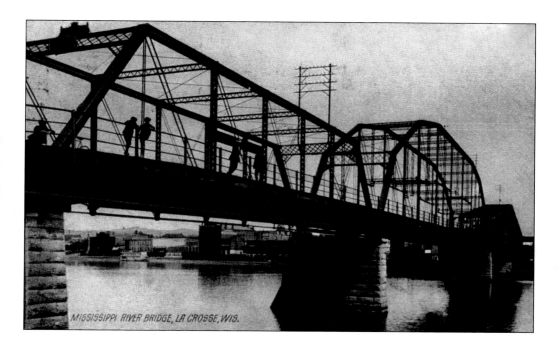

MISSISSIPPI RIVER BRIDGE, LA CROSSE, WIS.

**TWO BRIDGES, ONE BEACH.** Prior to 1939, Pettibone beachgoers reached their destination via the 1890 Mount Vernon Street Swing Bridge, seen above. This bridge was directly connected to the original bathhouse. Built before the age of the automobile, the wagon bridge, as it was better known, was never intended to bear the weight and stress of cars and trucks. This became sorely evident in 1935 when a car careened into the guardrail causing the bridge to collapse. The wagon bridge was repaired and continued to serve until 1939, when a new high bridge called the Cass Street Bridge, seen below, was completed. The 2,533-foot Cass Street Bridge spans the main channel of the Mississippi River. It cost $280,000 and took more than 300 men to construct.

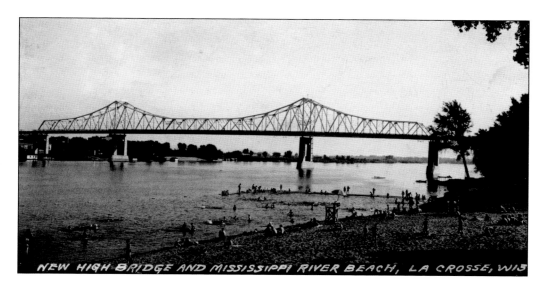

NEW HIGH BRIDGE AND MISSISSIPPI RIVER BEACH, LA CROSSE, WIS

**CITY HOMECOMING.** The pennants in these images tout that the week of June 28, 1914, is one of celebration, featuring a citywide homecoming, Made-in-La-Crosse Week, and the Fourth of July. Many former citizens traveled to the city, staying with friends and relatives. On the opening day, Mayor Ori Sorensen stated, "La Crosse is inaugurating today the biggest celebration in the history of the city." The board of trade, city government, and citizen committees organized boat races, picnics, exhibits, parades, and receptions. In the image below, Anton Linker and Jennie Edwards, with their friends in back, ride past a young Waneata Wensole near Fifth and King Streets during the automobile parade, which featured nearly 150 flower-clad cars. The *La Crosse Tribune* reported of the event that the "beautifully decorated autos filled with pretty girls attract thousands."

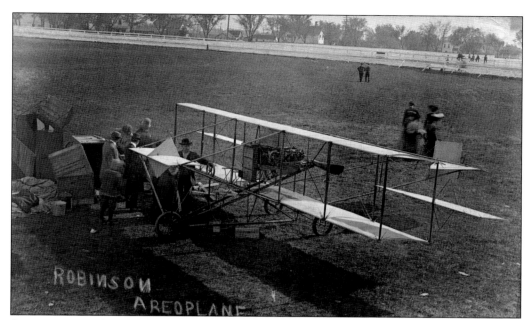

**Aviation.** Hugh Robinson piloted the first flight in La Crosse on October 12, 1911. In this image his Curtiss Flyer biplane is being assembled on the interstate fairgrounds. Robinson flew underneath the river bridge that connected La Crosse to La Crescent, Minnesota, thrilling a crowd of 10,000 people watching from the levee.

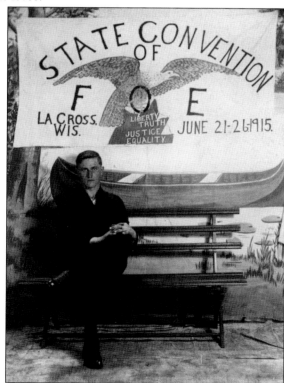

**Eagles, Wisconsin State Convention.** Pictured here is a man believed to be Charles Dittman, secretary of the La Crosse Fraternal Order of Eagles, Aerie No. 1254. He is sitting under a banner advertising the 1915 statewide Eagles convention held in La Crosse. This convention featured steamboat rides, parades, and auto trips. Later, in 1922, Dittman was elected state president of the Eagles.

**BLACKSMITHS ON LABOR DAY, C. 1910.** Posing here is the Labor Day parade unit for the International Brotherhood of Blacksmiths and Helpers, La Crosse Local No. 468. The organization was chartered in January 1905 with 26 members. The area's railroad companies employed most of these blacksmiths, who typically worked 10-hour-long days.

**RAILMEN ON LABOR DAY, C. 1908.** Members of the International Association of Car Workers, La Crosse Lodge No. 87, are seen here wearing their parade badges. In 1915, the group's name changed to the American Federation of Railroad Workers. In the organization's national journal, members of this lodge reported that they planned to attend the city's Labor Day celebration, "as we were told that we made one of the best showings in the parade last year"

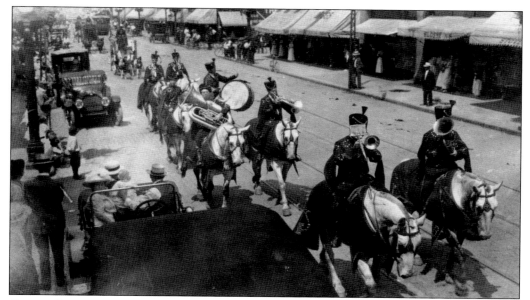

**CIRCUS PARADE, 1922.** In this image, a mounted circus band parades up Main Street. Behind the band are pony-drawn wagons and, farther back, a city streetcar. The awning for Klosheim's Hat and Blouse Shop, 421 Main Street, is seen to the right. Traveling circuses commonly used parades to drum up business when they arrived in a city.

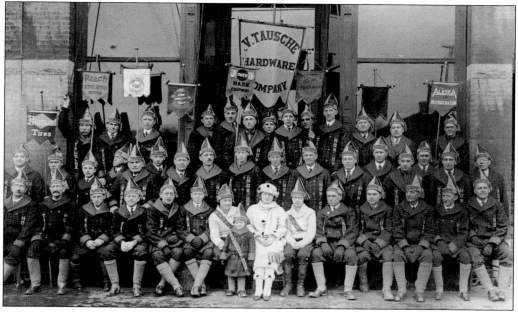

**WINTER CARNIVAL.** This marching club representing the Vincent Tausche Hardware Company marched in the La Crosse Winter Carnival Parade held in January 1922. In addition to the parade, the second annual winter carnival elected royalty and organized a ski jumping tournament. The theme for the event was "As They Played." Located at 201 Fourth Street South for many years, Tausche Hardware was in business from 1856 until 1969.

After the Storm - "Burns Park", La Crosse, Wis.

COPYRIGHTED 1907 BY G. E. MARINER

**EVENTFUL WEATHER.** No matter the decade or century, winter weather and insurmountable snowfall remain a constant fact of life in La Crosse. Pictured above is a snowy scene after a 1907 storm blew through the area. Local pharmacist and amateur commercial photographer George Mariner captured the Burns Park image. Selling a variety of photography equipment in his drugstore, Mariner, in addition to his main occupation, encouraged others to undertake the hobby of photography. The August 1907 image below shows storm damage the Michel Brewing Company suffered. An autumn storm bearing high-speed winds knocked over the brewery's smokestack. The postcard sender writes, "Say that storm was something fierce down here."

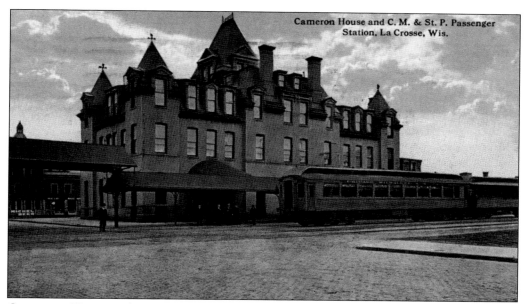

**CAMERON HOUSE.** This structure was an impressive passenger depot and hotel, built in 1879 and located near the Chicago, Milwaukee, & St. Paul Railroad at Second and Vine Streets. The interior featured red oak, white ash, and maple trimmings and was decorated with Brussels carpets and ebony furniture. It also offered modern amenities such as steam heat, gas lighting, an intercom system, and private bathrooms for the wealthier guests.

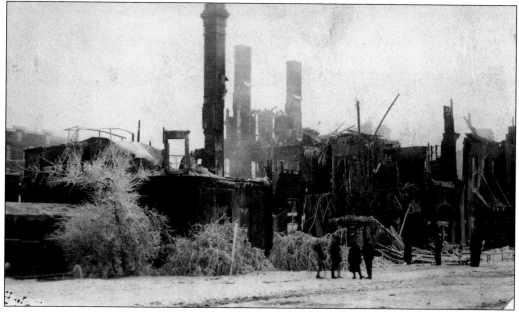

**CAMERON HOUSE, FIRE.** A spectacular fire broke out on Christmas Eve morning 1916. Brought under control by noon, this blaze was fought in subzero temperatures by all five of the city's fire companies. The fire caused the Cameron House to collapse, leaving only ruins covered in ice, as seen here. There were no fatalities, but the building was destroyed, amounting to over $50,000 in damages.

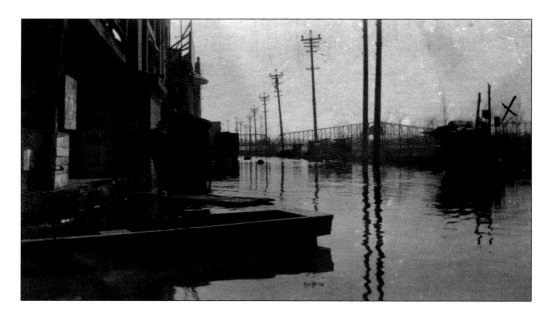

**FLOODING.** Like most river towns, La Crosse has experienced its fair share of floods. The image above shows the once dry landing along the waterfront completely engulfed in floodwaters. In the background, note the railcar indicating the location of the railroad tracks. La Crosse's waterfront structures were normally built with a high foundation and thick ground floors of stone rather than the normal brick construction. Also, they often had loading doors for freight on both the ground level and second floor, so that in times of high water business would not be interrupted. In the image below, a flood scene from the city's North Side is shown. The La Crosse Rubber Mills is visible in the background, and in the foreground, a local resident struggles to travel northward in the floodwaters.

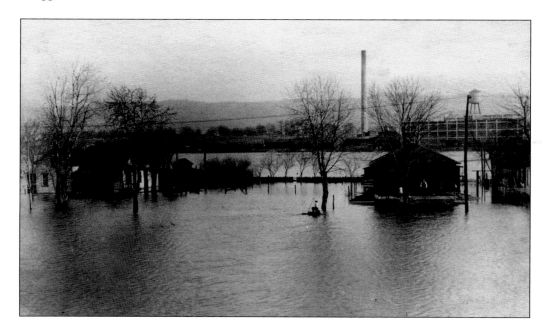

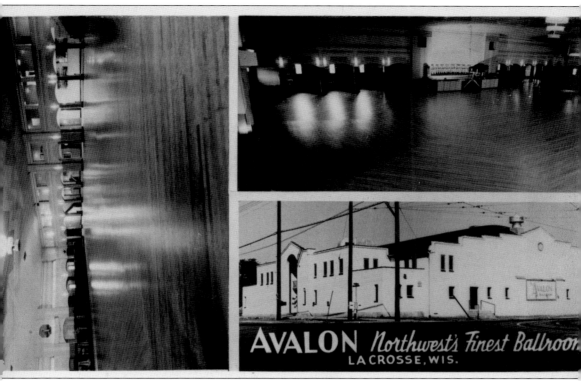

**AVALON BALLROOM, C. 1940.** Many a couple cut a rug at the Avalon, open from 1927 to 1967 on the city's North Side at 206 Copeland Avenue. On March 21, 1937, a substantial fire swept through the building, which was erected to replace the Rainbow Gardens dance hall that burned down on a different North Side site. The fire forced repairs to the Avalon, such as the installation of a new 5,670-square-foot dance floor, as seen in this image. The original 1927 twinkling-star ceiling, created by gently flickering lights shining through a screen, was completely destroyed and could not be replaced. The Avalon could accommodate 1,800 to 2,400 people. Some of the major musical acts that played there include the Beach Boys, Lawrence Welk, the Everly Brothers, and Louis Armstrong, and, in 1939, Joe Louis boxed there! The dance hall was sold in 1967 and was remodeled into Nino's Steakhouse. Since 1987, the building has housed a Chinese restaurant.

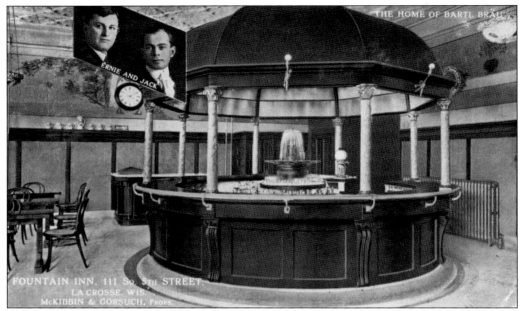

**FOUNTAIN INN, C. 1917.** The 1917 city directory lists 149 saloons in La Crosse. The Fountain Inn's entry states, "Imported and domestic wines, liquors, and cigars. Delicatessen served." This tavern featured a circular bar with a distinctive flowing fountain in the center. In 1919, the Fountain Inn, along with the city's other saloons, was forced to close due to Prohibition.

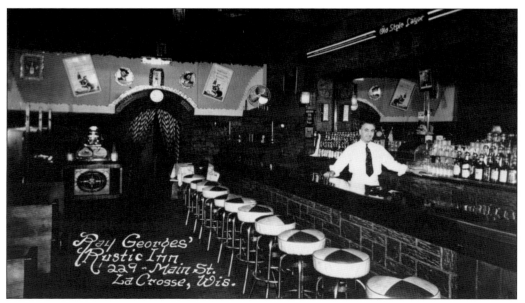

**RUSTIC INN.** Prohibition ended in 1933. While there is no listing for saloons or taverns in the 1934 city directory, it does list 145 businesses as "Beverage Dealers-Retail." Among those is the Rustic Inn, which Ray George and his wife, Eleanor, ran for 37 years. It was located at 229 Main Street. The last listing for the Rustic Inn appears in the 1983 city directory.

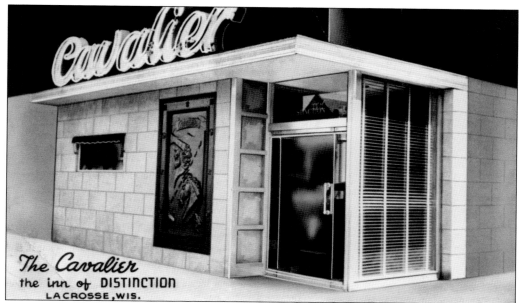

**CAVALIER LOUNGE.** John Sheetz, better known as Jack, opened the Cavalier in 1934 as an upscale cocktail lounge, and it is still found at its original 114 Fifth Avenue North location. La Crosse's musical history hit a high note in 1940 when Sheetz hired a then little-known piano player named Walter Liberace to perform at his establishment for 14 weeks. The Cavalier's modern Art Deco style is a significant departure from traditional taverns like the Rustic Inn, seen on the previous page. The Cavalier eventually closed, but in 2002, new owner Chris Kahlow restored and reopened the establishment. It closed yet again in 2010, but Jason LaCourse reopened the space and, a few years later, purchased the neighboring theater building. Upon that purchase, LaCourse restored the preexisting, though blocked-off, passageway between the two establishments.

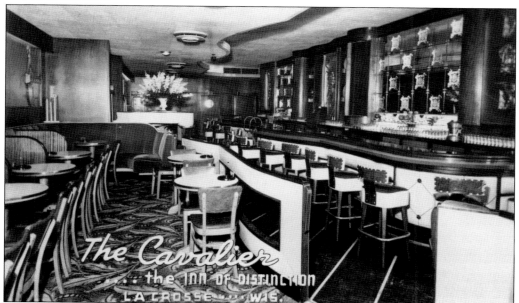

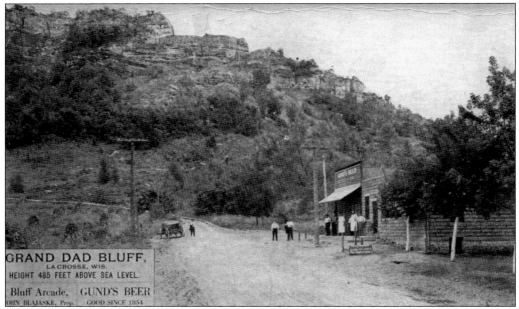

**BLUFFSIDE INN.** The pictured tavern has operated at the foot of Grandad Bluff for over 100 years. In this turn–of–the–century view, the name of the tavern is the Bluff Arcade, which proudly served the Gund Brewing Company's Peerless beer. The current name of the business is the Bluffside Inn.

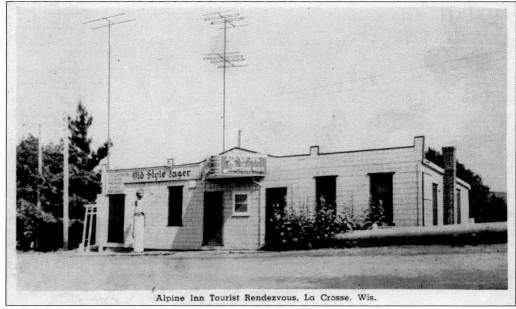

Alpine Inn Tourist Rendezvous, La Crosse, Wis.

**ALPINE INN, c. 1954.** Located near the top of Grandad Bluff (1,200 feet above sea level and 600 feet above La Crosse), this business was originally a soda and souvenir stand. It received a license to sell beer in 1938. Milton Isler owned the Alpine until 1978, when he sold it to James and Susan Olson. The building has gone through many alterations over the years and remains a popular stop for sightseers.

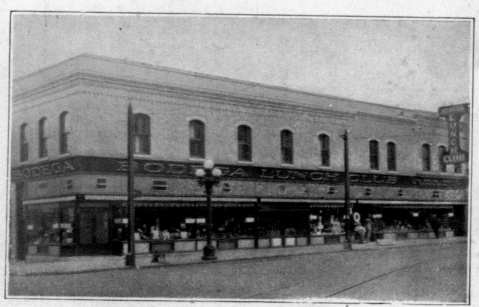

In the Heart of the Wine ...

BODEGA LUNCH CLUB

GOOD MEALS    GOOD SERVICE

Cigars, Delicatessen, Candy, Soda Fountain

**BODEGA.** This downtown landmark located at the corner of Fourth and Pearl Streets traces its roots back to 1897 when Jule Freas took over the Monarch Saloon at 329 Pearl Street, where he worked as a wine clerk. The new proprietor renamed the business the Bodega, selling wine, liquor, and cigars—the same products as its predecessor. Freas leased more space in surrounding buildings, expanding into 120 Fourth Street South in 1909 and into a former corner grocery store at 331 Pearl Street in 1926. Freas knocked down walls to connect these once separate buildings. It is believed that the iconic plate-glass windows were installed during the extensive renovation needed for the 1926 expansion. To survive Prohibition, the Bodega starting serving food, soda, and candy, eventually becoming a popular eatery. The business closed in 1989. However, it reopened in 1994 under the ownership of Jeffrey Hotson as the Bodega Brew Pub. In June 2014, Hotson held a celebration commemorating his 20th year in business.

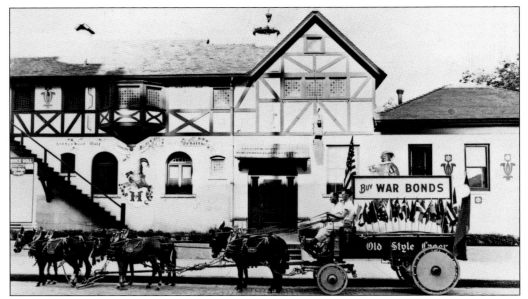

**WAR BONDS.** Pictured is an Old Style Lager wagon, decorated with the national flags of the Allies during World War II. It was used to promote the purchase of war bonds. The wagon is parked in front of the Heileman Brewing Company's bottling house. In 1943, the *La Crosse Tribune* reported that the city's residents had bought enough war bonds to purchase a Boeing B–17 Flying Fortress bomber airplane.

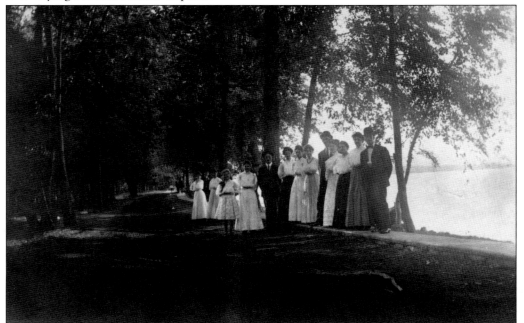

**PICNIC, 1912.** Here, the members of the Our Daughters of Toil Sewing Club enjoy a Sunday picnic at Pettibone Park. Perhaps the young ladies named their club with tongues firmly planted in cheek, but they seem to be enjoying their day of rest. Several gentlemen admirers join them on their outing as they pose for a photograph along the banks of the Mississippi.

# ABOUT MURPHY LIBRARY

Special Collections and the Area Research Center (ARC) at Murphy Library, University of Wisconsin–La Crosse supports original research and unique academic needs. This noncirculating section of the library contains fine and private press publications, maps, regional poetry, university records and publications, rare books, and an early science-fiction collection. This is also where the university's oral history program houses its interviews and transcripts. The Area Research Center is one of 14 regional repositories for the Wisconsin Historical Society (WHS). It is a source for distinctive primary resources from both public records and manuscript collections.

The most popular resources in Special Collections are photographs from its collections that contain images dating from the 1870s to today. The steamboat collection has approximately 50,000 photographs of inland river steamboats and river scenes, making it one of the nation's largest collections for this subject matter. With over 100,000 images, the other major collection consists of historical photographs of La Crosse and the surrounding area. It is from this extensive collection of local iconography that the historical postcards for this book were gleaned.

# Discover Thousands of Local History Books Featuring Millions of Vintage Images

Arcadia Publishing, the leading local history publisher in the United States, is committed to making history accessible and meaningful through publishing books that celebrate and preserve the heritage of America's people and places.

## Find more books like this at
## www.arcadiapublishing.com

Search for your hometown history, your old stomping grounds, and even your favorite sports team.